WHY A PAINTING IS LIKE A PIZZA

Wayne L. Roosa

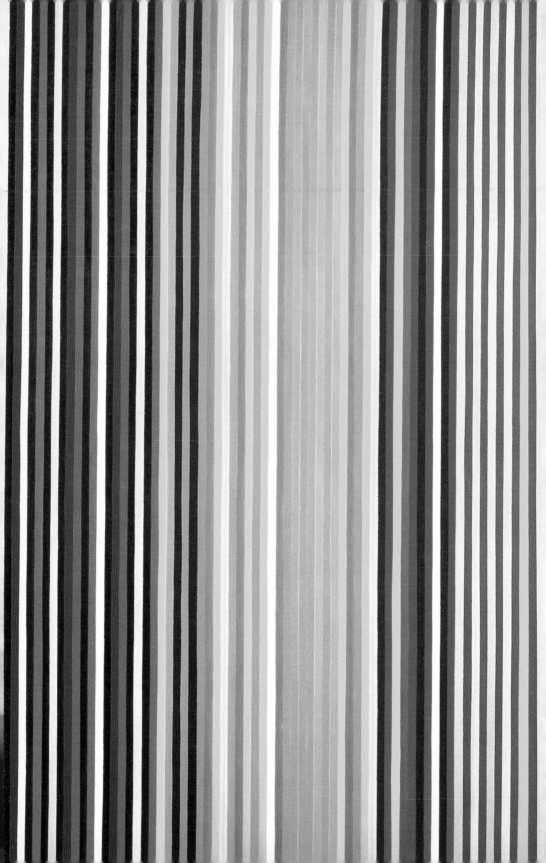

WHY A PAINTING IS LIKE A PIZZA

A Guide to Understanding and Enjoying Modern Art

NANCY G. HELLER

PRINCETON UNIVERSITY PRESS
Princeton and Oxford

FRONT COVER: (UPPER RIGHT) *Pizza with vegetable toppings* (detail); (LOWER LEFT) Jackson Pollock, *Number 3, 1949: Tiger* (detail), 1949. Hirshhorn Museum and Sculpture Garden, Smithsonian Institution, Washington, D.C. Gift of Joseph H. Hirshhorn, 1972. © 2002 The Pollock-Krasner Foundation / Artists Rights Society (ARS), New York. Photographer: Lee Stalsworth FRONTISPIECE: Gene Davis, *Moondog*, 1965. Detail of plate 18

Published by Princeton University Press,
41 William Street, Princeton, New Jersey 08540
In the United Kingdom: Princeton University Press,
3 Market Place, Woodstock, Oxfordshire OX20 1SY
www.pupress.princeton.edu

Designed by Patricia Fabricant
Composed by Tina Thompson
Printed by South China Printing

Manufactured in China
(Cloth) 10 9 8 7 6 5 4 3 2 1
(Paper) 10 9 8 7 6 5 4 3 2 1

Library of Congress Cataloging-in-Publication Data
Heller, Nancy G.
 Why a painting is like a pizza : a guide to understanding
 and enjoying modern art / Nancy G. Heller.
 p. cm.
 Includes bibliographical references and index.
 ISBN 0-691-09051-3 (cloth : alk. paper)—
 ISBN 0-691-09052-1 (pbk. : alk. paper)
 1. Art, Modern—20th century. 2. Art—Appreciation.
 I. Title.
 N6490 .H42 2002
 759.06—dc21 2002022725

CONTENTS

PREFACE

As THE CHILD OF A PROFESSIONAL ARTIST, I grew up surrounded by a wide variety of original paintings, sculptures, and prints—some made by my father, and others by his artist friends. For years I assumed that this was normal since, for my family, art—including abstract and otherwise unconventional art—wasn't some esoteric mystery; it was my father's job. Therefore, our "private collection" seemed no more remarkable than the stationery someone else's father sold for a living, and considerably less exciting than the chocolates stockpiled by a schoolmate whose dad worked for a candy company. As I grew older, though, I discovered that few other families displayed original art in their homes and that abstract art, in particular, was something most people only encountered, grudgingly, on field trips from school. As a result, after earning my doctorate in modern art history, I decided that I wanted to lobby on behalf of all types of nontraditional art.

During the last twenty years I have concentrated on the problems of understanding modern art, presenting public lectures (for Elderhostel, the Smithsonian Institution's Resident Associates Program, and the Pennsylvania Humanities Council) and writing articles for popular newspapers and magazines. In so doing, I try to convince other adults that they need not feel intimidated by such art—even if they dislike it. People tend to resist, or at least feel uncomfortable around, ideas and objects

that are unfamiliar. But visual art is such an important part of contemporary culture that many people with no background in the arts still feel compelled to understand it. Therefore, I've written this user-friendly guide, which—even though it obviously cannot substitute for studying art seriously, whether in an academic setting or independently—can give interested readers a simple, straightforward way of looking at, and thinking about, modern art in general and abstract art in particular.

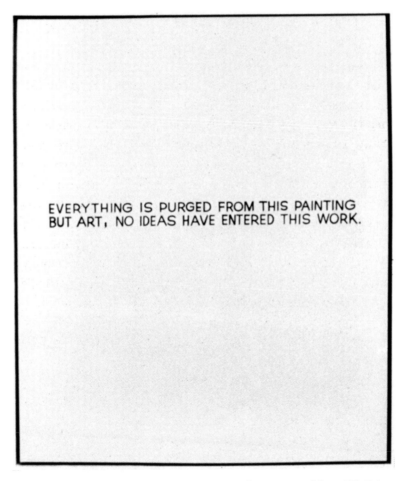

1. John Baldessari (American, born 1931), *Everything Is Purged from This Painting but Art; No Ideas Have Entered This Work*, 1966–68. Acrylic on canvas, 68 x 56 in. (172.7 x 142.2 cm). Courtesy of the artist

2. Patrick McDonnell, "Mutts,"
1998

INTRODUCTION

"We must remember that art is
art. Still, on the other hand,
water is water—and east is east
and west is west, and if you take
cranberries and stew them like
apple sauce, they taste much
more like prunes than rhubarb
does."

Groucho Marx, in
Animal Crackers, 1930

A PAINTING REALLY *IS* LIKE A PIZZA, in a surprising
number of ways. This is something I realized, at the ripe old
age of twenty-eight, when I cooked my first pizza from scratch.
At the time I was teaching art history in a small east Texas
town, where only one local restaurant served pizza. Since the
tomato pies sold by that establishment bore little resemblance
to the pizzas I'd known and loved in New Jersey, I took the radi-
cal step of consulting a recipe, purchasing ingredients, and
concocting my own customized pizza. The results were decid-
edly mixed, but the taste was superior to anything then avail-
able outside Dallas. More important, the process of making my
own pizza led to an epiphany—which in turn determined the
title of this book.

A detailed, point-by-point comparison of a particular
painting with a specific pizza will be provided at the beginning
of chapter 2. Right now, though, I would like to point out two
critical ways in which these apparently dissimilar items are

related. Both paintings and pizzas depend on visual balance for much of their overall impact, and though each can be judged by a set of generally accepted standards, ultimately the viewer/consumer must evaluate each painting and pizza in terms of her own personal taste.

That first Texas pizza reinforced for me the basic principles of two-dimensional design. It was easy enough to fashion the proper shape by using a round pizza pan, but it proved much harder than I had expected to create a pleasing surface pattern with the toppings I had chosen. To understand the importance of such compositional balance, think how you would feel if the restaurant where you had ordered a pepperoni-and-mushroom pizza with green peppers and black olives presented you with a pie that had all the pepperoni slices crowded onto one edge. It would be far more satisfying to look at, and eat, a pizza that had all four toppings spread out evenly across the crust. Paintings achieve a comparable sense of visual balance by a variety of means, but the end result is the same: a canvas that "feels" right when you look at it.

The importance of personal taste seems obvious when dealing with a pizza. Anyone who's ever worked in an Italian restaurant knows that people order their pizzas in all sorts of ways: with a thin or a thick crust, lightly browned or well done; with tomato sauce, white sauce, or some other more exotic variant; and topped with anything from pineapple wedges to shrimp, artichoke hearts, or escargots. Only the most arrogant foodie would maintain that just one of these is the "true" pizza. Individual attitudes toward paintings are just as varied—and just as valid. Yet otherwise reasonable people often feel free to dismiss whole groups of paintings and sculptures that they dislike, or that make them uncomfortable, even declaring that they are not art at all. My position is that anything anyone says is art should in fact be regarded as art. Rather than asking, Is X art? I prefer

> "That others grasp what I have in mind seems unessential, at least as long as they have something else in theirs."
>
> Alexander Calder, 1951

to ask, Is X a kind of art that I find interesting? If not, I won't spend much time looking at or thinking about X. But it is pointless to deny that it is art simply because I don't like it or because it challenges traditionally accepted ideas about what art is supposed to be. The marvelous thing about art is that it is a vast, amorphous, ever-expanding category, one for which great thinkers have struggled over the ages to provide a precise definition. Moreover, as we will see in chapters 5 and 6, even the most established definitions of art have been frequently challenged over the past century.

The purpose of this book is not to survey the recent history of art or to convince anyone to like all types of modern art. Rather, it is to encourage both casual and devoted gallery- and museumgoers to feel more comfortable around art they don't understand by demonstrating that all art, no matter how strange it may seem, is made up of similar aesthetic elements. Therefore, even the most avant-garde art can be looked at, and analyzed, in much the same way as traditional works. The illustrations in this book are taken mainly from the Western world and emphasize paintings and sculptures rather than architecture, prints, photographs, crafts, performance art, or video. However, most of the principles discussed here also apply to other types of art—from various periods, places, and cultures. The main point is that all sorts of visual art—like all kinds of music, literature, film, dance, and theater—can be a source of tremendous pleasure. Traditional paintings, sculptures, prints, drawings, and photographs have long been appreciated in this way; my intent here is to make it clear that art with no apparent subject matter, and even art that is difficult to recognize, at first, as art, can also provide viewers with great intellectual stimulation and sheer, visceral joy. More than that, avant-garde art can transform our perceptions, enabling us to see, feel, and think about the world in a completely new way.

"The most significant thing an artist can do is change our way of seeing."

Milton Glaser,
Time magazine, 16 April 1990

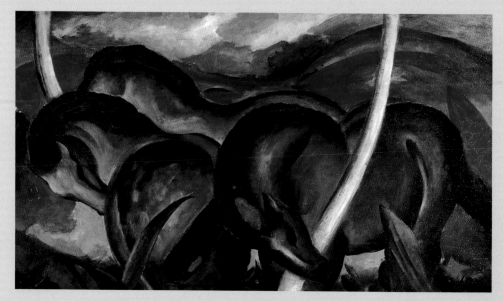

3. Franz Marc (German, 1880–1916),
The Large Blue Horses, 1911. Oil on
canvas, 41⅝ x 71⅜ in. (105.7 x 181.1 cm).
Walker Art Center, Minneapolis.
Gift of the T. B. Walker Foundation,
Gilbert M. Walker Fund, 1942

EXACTLY WHAT IS "ABSTRACT" ART?

1

"Art. This word has no definition."

Ambrose Bierce, *The Devil's Dictionary*, 1906

Before we go any further with this discussion, I need to define a few words. This is particularly necessary since both *modern* and *abstract* art, two terms that are central to this book, have been used differently under various circumstances. For example, my Ph.D. was officially earned in the field called modern art history. Traditionally, this label referred almost exclusively to European painting, sculpture, and architecture produced between roughly 1789 and World War II. To make it even more confusing, some specialists in the Italian Renaissance call the art of the fourteenth and fifteenth centuries modern. Moreover, many art historians, critics, and artists use the terms modern art or modernist art specifically in referring to the various movements such as Fauvism, Expressionism, Cubism, and Surrealism that developed in Europe during the first part of the

twentieth century, plus later European and American spin-offs of those movements. *Contemporary* art, on the other hand, is recent art, the art of one's own day.

In this book I will use the term modern art very generally, to refer to avant-garde art made from about 1900 to the present. However, even this requires some additional explanation, given the recent disputes among scholars concerning "avant-garde" art. The term *avant-garde* comes originally from the military, where it refers to the first set of troops sent into battle. In terms of visual art, avant-garde has generally been applied to the leaders of convention-breaking modern movements. Until recently, twentieth-century art history, in the Western world, was viewed largely as a succession of these revolutionary movements, all consciously designed to break away from the restrictive traditions of the past. Avant-garde art from the early 1900s emphasized the new, looking toward a future shaped by the extraordinary technological developments that emerged around the turn of that century. In such a world, these artists reasoned, old ideas about art could have no more relevance than outdated notions about science, technology, or anything else.[1]

Because most gallery and museum visitors feel relatively comfortable dealing with traditional art, this book is focused on the unconventional, the avant-garde. Such art encompasses a broad range of approaches, but one of its most challenging aspects is still abstraction, even though abstraction has been around for nearly a hundred years. *Abstraction* is not an absolute term. It may refer to art that stylizes, simplifies, or deliberately distorts something that already exists in the real world. Alternatively, there is "pure" abstraction (also known as "nonobjective" or "nonrepresentational" art), which does not depict anything from the real world. Purely abstract art is an arrangement of colors and forms that are not intended to look like anything other than the artwork itself.

"I paint objects as I think them, not as I see them."

Pablo Picasso

Yet pure abstraction is not without content. There is a dif-

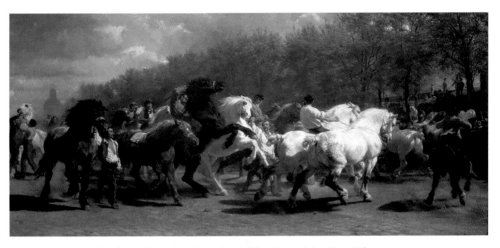

4. Rosa Bonheur (French, 1822–1899), *The Horse Fair*, 1853. Oil on canvas, 8 ft. x 16 ft. 8 in. (2.4 x 5.1 m). The Metropolitan Museum of Art, New York. Gift of Cornelius Vanderbilt, 1887 (87.25)

ference between subject matter, in the usual sense of the term (say, a person or a vase of flowers), and content. The content in a totally abstract painting is that intangible set of thoughts and emotions put there by the artist, which—in an ideal situation— can be communicated to a sympathetic viewer. Obviously, no one could discern the specific intellectual or emotional content that an artist has put into such a work. However, the viewer's own, possibly very different ideas and feelings can often be triggered by a nonobjective painting or sculpture.

Most artworks fall somewhere between realism (depicting things the way they appear in the observed world) and pure abstraction. Some sense of the many degrees between these two poles is evident from comparing five very different artworks, all based on the same real-world subject.

Rosa Bonheur's *The Horse Fair* (plate 4)—an enormous, and enormously successful, nineteenth-century French painting— is clearly on the realist end of the spectrum. Coming from a tradition in which absolute fidelity to appearance and technical virtuosity were essential to an artist's reputation, this canvas is based on Bonheur's many years spent studying both painting and animal anatomy and behavior. It also reveals her great love

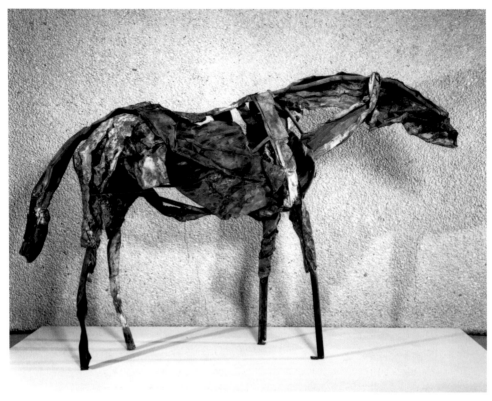

5. Deborah Butterfield (American, born 1949), *Horse,* 1985.
Construction of painted and rusted sheet steel, wire, and steel tubing,
6 ft. 10 in. x 9 ft. 11 in. x 2 ft. 10 in. (2.1 x 3 x 0.9 m). Hirshhorn Museum and
Sculpture Garden, Smithsonian Institution, Washington, D.C. Thomas M.
Evans, Jerome L. Greene, Joseph H. Hirshhorn, and Sydney and Frances
Lewis Purchase Fund, 1985

of horses, which she owned throughout her long life. In this painting, Bonheur depicts a multitude of horses in various colors and wildly varied poses, carefully positioned within the clearly defined pictorial space. Her attention to detail is mesmerizing. Moreover, as men struggle to control the animals, the artist conveys a clear sense of the energy, drama, and danger inherent in such a scene.

The Large Blue Horses by Franz Marc (plate 3) differs from Bonheur's picture in nearly every way imaginable. Instead of capturing the individual personalities of believable horses, the German painter created an equine trio that could never exist in real life. In addition to using an exaggerated color scheme, Marc intentionally stylized the horses' heads and bodies. There are few details. Rather, he abstracted these creatures into a series of broad curves—curves that are echoed in the tree trunks, the foliage, and the red hills beyond. The Large Blue Horses was painted nearly sixty years after Bonheur's canvas, by which time Expressionist artists like Marc had significantly changed their ideas about the purpose of art. Depicting actual horses was no longer enough; Marc had to reinvent them with his own highly personal sense of color and form.[2] Yet despite the liberties Marc took with his subjects, it is still easy to recognize them as horses.

The contemporary American sculptor Deborah Butterfield made her reputation during the late 1970s with a series of life-size horses fashioned from found materials (discarded bits of wire, wood, and steel). Like Bonheur, Butterfield has always been obsessed with horses—training them, riding them, even considering a career as a veterinarian. However, despite her in-depth knowledge of equine anatomy, Butterfield has chosen to create images of horses that merely suggest their forms and movements. The horse illustrated here (plate 5) is obviously not intended to seem real. It stands on hoofless, sticklike metal "legs"; it has no eyes, ears, nostrils, or mouth; and gaping holes go right through its torso and neck. It's almost as though Butterfield has made a quick three-dimensional sketch of a horse. Yet her abstracted sculpture still manages to capture the strength and grace of the subject.

For the last century or so, cutting-edge art has tended to become more and more abstract. However, there have been exceptions to this trend, particularly among the so-called postmodern artists, who have frequently turned back the clock, stressing exquisite, detailed realism in their own work—but with an ironic twist. An example of this phenomenon is the art of the British painter Mark Wallinger, whose trompe-l'oeil horse pictures (so real that they look like photographs) were part of the notorious *Sensation* exhibition that opened at the Brooklyn Museum of Art in October 1999 (plate 6). At first, Wallinger's extraordinary command of his medium (oil paint—the same as Bonheur's), and his thorough knowledge of his subject make his horses seem like a throwback to an earlier era. But on second glance, his horses look completely different from Bonheur's, except for the uncanny realism of their faces and coats. Whereas her canvas, like most traditional animal paintings, places the subject in an appropriate, clearly delineated context, Wallinger's horses stand isolated within an unarticulated, unexplained, otherwise empty white space. They float, as though they were models for a print ad being photographed against a roll of seamless paper. In addition, the compositional device of simply implying the presence of human beings through the reins that curve off the edge of the pictures would never have appeared in a nineteenth-century painting. Wallinger's evocative, and ironic, title for this series, *Race Class Sex*, further reveals the enormous gulf between his horse images and earlier examples.

"Art does not lie in copying nature. Nature furnishes the material by means of which to express a beauty still unexpressed in nature. The artist beholds in nature more than she herself is conscious of."

Henry James

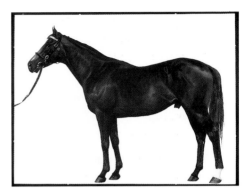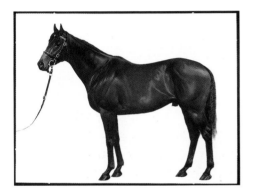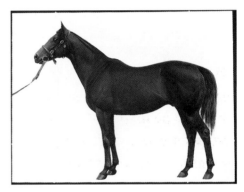

6. Mark Wallinger (British, born 1959), *Race Class Sex*, 1992. Oil on canvas (set of four paintings), each painting 7 ft. 6 in. x 9 ft. 10 in. (2.3 x 3 m). The Saatchi Gallery, London

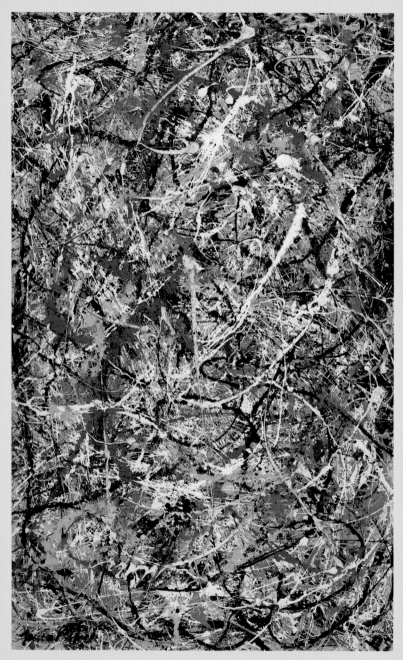

7. Jackson Pollock (American, 1912–1956), *Number 3, 1949: Tiger,* 1949.
Oil, enamel, metallic enamel, string, and cigarette fragment on
canvas mounted on fiberboard, 62⅛ x 37¼ in. (157.7 x 94.5 cm).
Hirshhorn Museum and Sculpture Garden, Smithsonian Institution,
Washington, D.C. Gift of Joseph H. Hirshhorn, 1972

WHY *IS* A PAINTING LIKE A PIZZA?

2

> *"To see is itself a creative operation, requiring an effort."*
> Henri Matisse

TO SEE PRECISELY how a painting is like a pizza, let's compare plates 7 and 8. This kind of comparison is known as a "formal analysis"—meaning that it concentrates exclusively on the appearance (form) of the object in question rather than considering other relevant points, such as the artist's biography, the theoretical underpinnings of the work, or the historical context in which it was produced. There are fashions in scholarship, as in everything else, and art historians—like literary critics—have traditionally concentrated on formal analysis, sometimes to the exclusion of virtually all other considerations. In recent decades the emphasis has shifted—in both the art and the literary worlds—to examining a work in terms of its broader sociopolitical significance. Nevertheless, straightforward formal analysis can still provide a great deal of insight into a work of art.

The pizza illustrated in plate 8 is a relatively typical example: round, approximately sixteen inches across, with a golden brown crust, covered with a layer of melted cheese, tomato sauce, and diverse toppings, each of which adds its own color, texture, and shape to the whole. In contrast, Jackson Pollock's *Number 3, 1949: Tiger* (plate 7) is rectangular and much larger: approximately three by five feet. It is made with three different kinds—and many colors—of paint, which have been poured across the canvas. Obviously, the purposes of these two objects are utterly different. And yet the presentation (how it looks when the waiter serves the pizza to the customer—or the art-moving company delivers the finished canvas to its new owner) is as important for the pizza as it is for the painting.

A well-made pizza, like the one illustrated here, generally offers a visually pleasing pattern of distinct ingredients—vivid red and green peppers, glossy black olives, translucent white bits of onion, light brown mushroom slices—arranged across the circular surface in a comfortably even way. Similarly, Pollock's painting, like his other quintessentially Abstract Expressionist canvases, features many strands of colored pigment, distributed across the work with remarkable evenness.[1] The compositions of Pollock's "poured" paintings (so called because he made them by pouring the color onto the canvases) may seem random at first.[2] But a closer inspection reveals that he clearly exercised aesthetic awareness and control. Trace the path of one of Pollock's colors (for example, the mustard yellow paint) and note how it recurs at strategic points all over the picture. The same can be said for the blue-gray marks and every other color Pollock used here. If too much of any one color were concentrated in a single area of the painting, the overall composition would seem unbalanced, just as the pizza would if too many olives were clumped together in one spot.

There are other visual similarities between this painting and this pizza. Both use the basic palettes of red, yellow, black, and green—although there is also blue-gray in the Pollock work. Moreover, both emphasize curving forms. The pizza does this, for example, in the olive slices and mushroom caps,

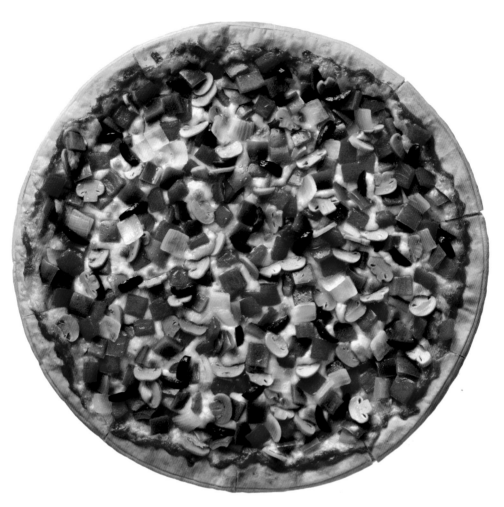

8. Pizza with vegetable toppings

both echoing the circular crust to which the entire composition is attached. Pollock's curving shapes reflect the movements of his hand and arm as he strode around the painting and the paths the liquid paint took as it landed on the canvas. The textures of this painting and pizza are also visually related, since both stress irregular surfaces—created by the uneven thickness of the vegetables, cheese, and crust, on one hand and, on the other, by Pollock's tendency to alternate relatively thin with extremely thick areas of paint. (The pizza is three-dimensional, of course, but sometimes Pollock's pigment gets so heavy that it even casts a shadow.)

Finally, the response to a pizza is determined, in part, by the way it is served—whether in a cardboard box or on a dinner plate of a particular size and color. In addition, everything surrounding the pizza, from the tabletop to the decor of the room, also affects how it looks. In the same way, the appearance of Pollock's painting is affected by various external elements, including its frame (assuming there is one): is it metal or wood? light or dark? thick or thin? ornamented or plain? The wall on which the painting is displayed, its lighting, the floor beneath it, and even the label also contribute to the impression that viewers receive. If you doubt the truth of this last point, just think about the difference between a pizza as it is presented in your favorite restaurant versus the same pizza taken out and consumed in your apartment, dorm room, or backyard. Few people have the opportunity to see the same painting in a number of different settings—whether a museum, commercial gallery, artist's studio, or collector's home, but the differences these venues make in the way the painting looks can be astonishing.

"Until I saw Chardin's painting, I never realized how much beauty lay around me in my parents' house, in the half-cleared table, in the corner of a tablecloth left awry, in the knife beside the empty oyster shell."

Marcel Proust

Part of the point of all this is to demonstrate that any object can be analyzed in purely visual (formal) terms. This kind of

analysis is not limited to art historians. Everyone is capable of—and virtually everyone makes—subtle aesthetic discriminations on a daily basis, generally without even being consciously aware of the process. An example of this phenomenon is recognizing the singer of a newly released song that you've never heard before, after half-listening to just a few seconds of the piece on the radio. Because we can all do this, we tend to take for granted the extraordinarily complex thought processes such recognition involves. Identifying the singer of an unknown song requires recognizing the range and timbre of a particular voice, plus the kinds of instrumentation, melody, and lyrics generally favored by the singer, as well as many other factors.

Moving from an aural to a visual example, think how easily you can tell the handwriting of someone you love—distinguishing it immediately from all the other examples of handwriting that might appear on the other envelopes in the day's mail. It is difficult to articulate precisely what tells you that one letter is from a particular person, but making this kind of visual discrimination is a nearly universal skill. Likewise, an automobile aficionado's ability to distinguish one make and model of car from all the others is generally accomplished without formal study, or even conscious effort. In the world of visual art, "connoisseurship" is the process of distinguishing, say, a Cubist still life by Pablo Picasso from one by Georges Braque, or a genuine Rembrandt etching from a forgery. This type of recognition is a skill that takes many years to develop, based on an in-depth, hands-on study of myriad works of art, plus—in most cases—extensive academic training. All of this background enables a connoisseur to analyze—and ultimately, to explain—his initial "gut" feeling, in a way that can be tremendously helpful for fellow scholars, collectors, and others.

Obviously, there are many differences between a painting and a pizza. In the end, one vegetarian pizza tends to resemble every other vegetarian pizza. More important, those differences that do exist—depending on which restaurant, and which chef, produced the pizza in question—are of relatively limited interest. Once the consumer determines which establishment makes

the vegetarian pizza she prefers, she will presumably return on a regular basis, precisely because she expects the product to be more or less identical every time. But a painting is quite different. The whole point of an original oil painting is that there can be only one. No matter how closely related a series of paintings might be, they are never exactly the same. Indeed, part of the pleasure in looking at any work of art comes from appreciating its utter uniqueness. An interesting painting—like an excellent book—can be pored over repeatedly, and each time the viewer will garner some new insight or thrill. A really superb pizza, on the other hand, has to be tasted before it reveals its best qualities, and naturally it cannot be eaten more than once.

It may be instructive (and, hopefully, amusing) to compare a painting with a pizza, but it is also helpful to compare two paintings that, although they are both made of the same materials, may at first seem far more different from each other than the tomato pie and Pollock's *Tiger*. Certain aesthetic elements are found in all works of art, from all countries and all eras, in all media and styles. Art students learn how to manipulate these elements, and regular viewers of art can also use them to appreciate (i.e., analyze, better understand, become more comfortable with) the art they observe. To demonstrate that all artworks are based on the same essential elements, we will compare a traditional, realistic painting from the Italian High Renaissance (Raphael's *La Belle Jardinière*; plate 9) and a totally abstract painting by the Dutch modernist Piet Mondrian *(Composition No. 8*; plate 10).

"The tendency is to assume that the representational as such is superior to the non-representational as such; that all other things being equal, a work of painting or sculpture that exhibits a recognizable image is always preferable to one that does not. Abstract art is considered to be a symptom of cultural, and even moral, decay, while the hope for a 'return to nature' gets taken for granted by those who do the hoping as they hope for a return to health."

Clement Greenberg, 1961

On first encounter, these works seem to have little in common. Both are relatively large images made with oil paint, but one is topped by a lunette (a half-moon shape popular during the Renaissance), while the other, like most twentieth-century pictures, is strictly rectangular. More significantly, one is a Christian devotional image, including all sorts of traditional symbols, such as the thin gold halo above each figure's head and the blue cloak and the camelskin garment that identify their wearers, respectively, as the Virgin Mary and the infant Saint John the Baptist. Mondrian's painting, on the other hand, has no subject matter, in the usual sense of that term. Raphael's canvas—a good example of sixteenth-century Italian humanism—is filled with exquisitely rendered details that make both the people and the landscape in which they sit seem very real, whereas there is no clear frame of reference for the Mondrian painting, which isn't an image of anything else.

Color is an important element in both paintings, but the two artists used it quite differently. Typically, Raphael stressed a rich, warm palette. Mary's red and blue garments are standard in an Italian altarpiece from that period, and the soft greens and browns in the foreground, like the colors of the mountains, trees, water, sky, and clouds, are all as they would appear in nature. Color is used here to reinforce the illusion that this is a real scene. It helps viewers accept the fact that Mary, whom believers revere as the Mother of God, also looks like an ordinary sixteenth-century Italian mother of a young boy. For Mondrian, color was both a means of enlivening his black-and-white compositional structure and a demonstration of his philosophical principles. The large red square in the upper left does not represent the setting sun, cherry-flavored Jell-O, or anything else from

> "There is sometimes added to the abstract forms something particular, even without the use of figuration; through the color or through the execution, a particular idea or sentiment is expressed. . . . All the world knows that even a single line can arouse emotion."
>
> Piet Mondrian, 1937

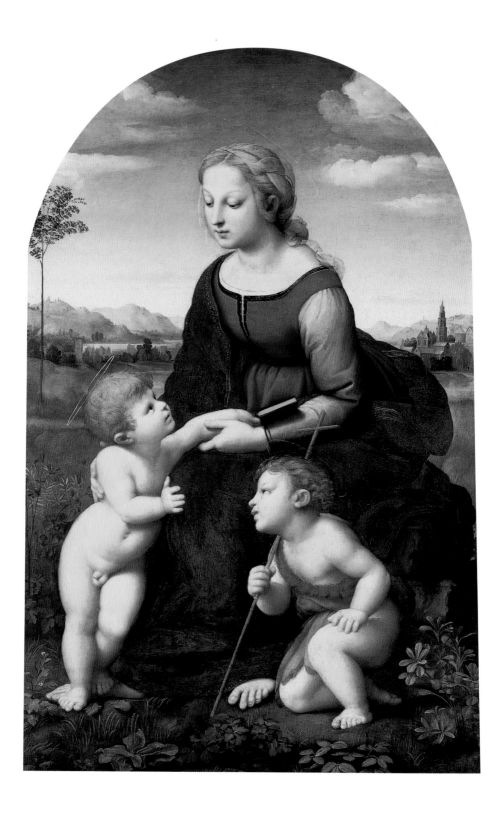

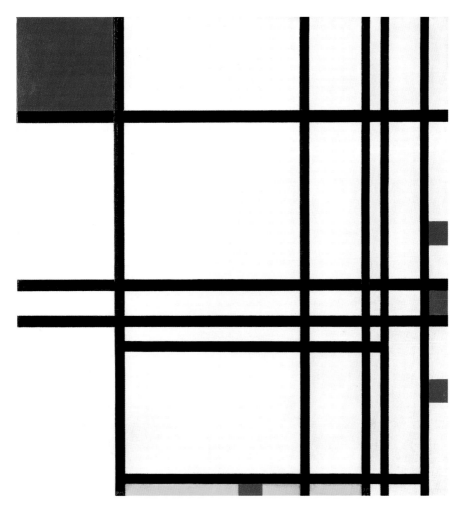

OPPOSITE
9. Raphael (Italian, 1483–1520), *The Virgin and Child with Saint John the Baptist*, known as *La Belle Jardinière*, 1507. Oil on wood, 48 x 31½ in. (122 x 80 cm). Musée du Louvre, Paris

ABOVE
10. Piet Mondrian (Dutch, 1872–1944), *Composition No. 8*, 1939–42. Oil on canvás, 29½ x 26¾ in. (74.9 x 67.9 cm). Kimbell Art Museum, Fort Worth, Texas

the real world. Its unmodulated tone (meaning that it is all the same shade of red) makes it seem like an abstract block of color rather than a picture of anything else that happens to be that color. Likewise, the small rectangles of red, yellow, and blue add visual interest.

Texture is not an especially important consideration in either of these paintings. Essentially, they both feature smooth, even layers of color throughout, with the brush strokes carefully blended together to create—in Raphael's case—the illusion of skin, cloth, grass, and fur, or—for Mondrian—a relatively uniform surface that does not distract from the overall design. Raphael also used modeling (gradations from light to dark) to reinforce the illusion of reality in his scene. For example, the Madonna's face and neck are shadowed on the side away from the sun—the imaginary light source within the picture. Likewise, the folds of her garments are modeled in light and dark passages, to make them appear to have weight and volume. Mondrian, however, avoided the use of modeling, making all his white sections the same kind of white and all the black lines the same shade of black, and giving the red and yellow portions of the canvas no indication of any light source.

One of the most interesting points of comparison between these two paintings is their overall composition—which is remarkably dynamic in both cases. In the Western world, the most typical way to construct a successful composition is through symmetry, balancing the left and right sides of a painting through the use of similar colors and shapes. In fact, in most of Raphael's many Madonna-and-Child-with-Infant-Saint-John pictures, the scene is essentially symmetrical, with the two children placed on either side of Mary, thus forming the popular Italian Renaissance "pyramid" structure, a particularly stable arrangement of forms.

La Belle Jardinière is indeed a pyramidal composition. Thus, the curving shape formed by the uppermost silhouettes of Mary and Christ echoes the rounded top of the panel itself. At the same time, Raphael kept this composition from becoming too static by introducing a number of subtle asymmetries that bal-

ance each other visually. For example, Saint John kneels while the Christ child stands, creating a diagonal line that runs from one little boy's head to the other. This parallels the background diagonal formed by the tall trees on Mary's right and the low buildings of the distant town on her left. Raphael further enlivened this image through Christ's unusually casual pose. He also stressed the physical interaction between mother and child, as Mary tenderly supports her son's back with her right hand, holding his forearm with her left. Christ actually stands on his mother's right foot, another intimate, charming, and humanizing detail.

Mondrian, too, balanced his composition dynamically, encouraging the viewer to see a parallel between the visual weight of the large red square and the small multicolored ones in the lower-right-hand corner of the canvas. The red elements are widely dispersed, and since bright colors inevitably attract our attention in this otherwise black-and-white painting, we end up shifting our gaze all around the canvas. If Mondrian's work were in fact symmetrical, with the big red form placed dead center and the other colored shapes more evenly distributed, this would undoubtedly be a far less successful painting. Also, even though he carefully avoided the use of diagonals, in this work Mondrian varied the visual rhythm of his composition by using the black lines to form an irregular grid that breaks up the white space into cells of different sizes. The use of parallel lines is also important, creating the illusion of space—for example, we seem to see "beyond" one set of black bars to the blue form placed "behind" it.[3]

Beginning in 1921, Mondrian placed severe restrictions on the elements in his paintings. Earlier he had depicted such standard subjects as trees, using many different colors and various types of brush strokes. However, his interest in the theories of theosophy (a system of

"In order to approach the spiritual in art, one employs reality as little as possible. . . . This explains logically why primary forms are employed. Since these forms are abstract, an abstract art comes into being."

Piet Mondrian, Sketchbook II, 1914

religious/philosophical beliefs established by Madame Elena P. Blavatsky in New York City in 1875), plus the ideas of M. H. J. Schoenmakers and other mystical thinkers of the time, changed Mondrian's approach to art. Ultimately, he rejected all references to external subjects. Instead, he concentrated on what he considered to be the most basic elements of painting: namely, straight lines and primary colors (plus black and white). His approach— known as Neoplasticism—was intended to reconcile such dualities as horizontal/vertical and mind/body, thereby creating what he referred to as "dynamic equilibrium." This equilibrium, in turn, was supposed to express the harmony of the universe.[4]

Clearly, the casual observer cannot be expected to discern the spiritual underpinnings of Mondrian's work. All art can be experienced on two levels. Viewers can take the time necessary to read about an artist's background and ideas; obviously, this is ideal. However, every artwork must also be able to stand on its own, to convey a strong aesthetic and visceral impression even to viewers who are totally unfamiliar with any of this information. For example, it is not necessary for the viewer to know anything about the artist's culture in order to appreciate the sheer beauty of Lucy Martin Lewis's work.

Plate 11 illustrates a complex and powerful artwork by Lewis that, like Mondrian's *Composition*, utilizes a severely limited number of colors (black and white) and the skillful repetition of a single form (a short, straight line) to create a dynamically balanced, abstract, allover surface—on a clay pot. One of the so-called matriarchs of American Indian pottery, Lewis was born and raised on Acoma Pueblo in an isolated part of New Mexico. Since the pueblo had no schools, she learned all her domestic and artistic skills from relatives. Even though her background could hardly be more different from that of Pollock, Raphael, or Mondrian, Lewis exhibited a similarly sophisticated understanding of aesthetics. Here, for example, she covered the outside of her jar with a series of intersecting eight-pointed stars, which seem to oscillate as you look at them, in the best tradition of 1960s-era Op art.

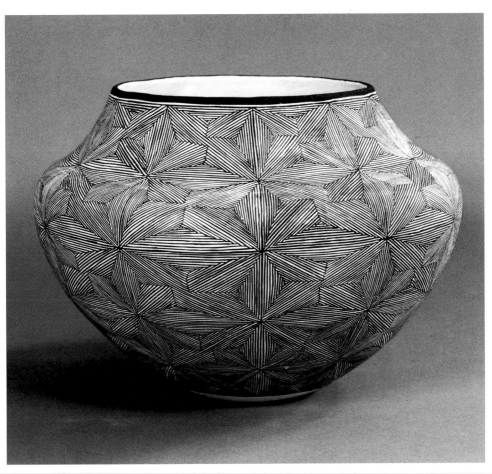

11. Lucy Martin Lewis (American, 1902–1992), *Jar*, Acoma Pueblo, New Mexico, 1983. Earthenware, height 9½ in. (24.1 cm), diameter 12 in. (30.5 cm). The National Museum of Women in the Arts, Washington, D.C. Gift of Wallace and Wilhelmina Holladay

Clearly, paintings are not the same as pizzas, nor are clay pots the same as compositions made with oil pigments on canvas. However, both the individuals who create these things and the people who look at (or eat) them have to consider remarkably similar factors, including a well-balanced composition, appealing textures and colors, and an effective presentation.

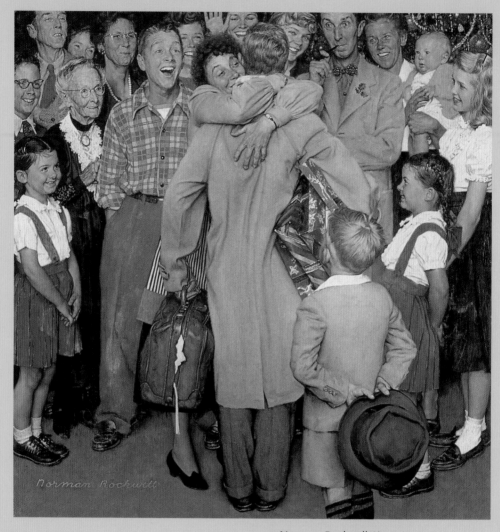

12. Norman Rockwell (American, 1894–1978), *Christmas Homecoming,* 1948. Oil on canvas, 35½ x 33½ in. (90.2 x 85.1 cm). The Norman Rockwell Museum at Stockbridge, Massachusetts

MAKING AESTHETIC DECISIONS IN ART AND IN DAILY LIFE

3

"I don't know much about art, but I know what I like."

Anonymous

EVERYONE HAS VISCERAL and very different reactions both to art and to the less esoteric objects that we all encounter in the course of daily life. We really *do* know what we like, in terms of everything from paintings to T-shirts. To be sure, trends can influence us, both in visual art and in fashion. Clothing-related trends change regularly, decreeing that certain fabrics, hemlines, or colors shall be in vogue for a period of time. But trends don't alter heartfelt personal preferences: if you really dislike animal prints, you won't like the newest designer-label faux-leopardskin shirts, no matter how many raves they may receive from fashion writers. Trends in the art world change almost as often, and certainly as dramatically, as any others, and they are equally subject to rejection on the basis of individual taste.

A particularly good example of this phenomenon is the work of the American artist Norman Rockwell (plate 12). From 1916 to 1963 his *Saturday Evening Post* covers made Rockwell a household name. Yet until recently his work was disdained by most art historians, who regarded him as a mere illustrator and his pictures as charming but insubstantial. When I was a graduate student, during the mid-1970s, it would have been unthinkable—and unacceptable—to write about Rockwell's art, which was not displayed in "serious" museums. However, attitudes about American popular culture and about the traditional distinction between illustration and fine art have changed during the intervening decades. As a result, people within the art world have taken a second (or possibly their first) hard look at Rockwell's paintings. Suddenly unfettered by prejudices against illustration, critics are noticing Rockwell's technical prowess; his interest in issues such as race, religion, and politics; and his surprising wit. In plate 12, for example, the welcoming crowd includes an affecting portrait of Grandma Moses (whose own career has also enjoyed a recent rebirth) and a sly self-portrait—on the right, smoking his ever-present pipe. A major retrospective exhibition of Rockwell's art toured the United States in 1999–2002, attracting huge crowds in seven cities. In New York it was shown at the prestigious Guggenheim Museum and received laudatory reviews by writers for such august publications as the *New Yorker,* the *New York Times,* and the *Nation.* Nonetheless, even though it is now fashionable to take Rockwell's art seriously, many people who never enjoyed his work still dislike it.

Changing trends aside, certain absolutes do make paintings and other artworks easier to evaluate—though not necessarily to like. For instance, some paintings have greater historical significance than others: because they were the first or most influential examples of some important development; because they achieved an unprecedented level of critical or commercial success (or failure); or for other reasons that can be clearly supported by facts. But the historical importance of an artwork has little to do with personal taste. For example, the elevated

place in art history held by the seventeenth-century French painter Nicolas Poussin is unquestioned. Yet I personally find his paintings boring. My own taste runs toward paintings that feature strong contrasts between light and dark areas, a great deal of implied movement, and contemporary (or no) subject matter. Thus, it is hardly surprising that I find it difficult to respond enthusiastically to Poussin's canvases, which typically stress static, evenly lit figures, based on stories—and sometimes specific sculptures—from the ancient world. After studying Poussin's art and life, I can more fully appreciate the extent of his erudition, his technical prowess, and the impact his enormous canvases clearly had on his contemporaries. Indeed, Poussin is widely regarded as having been the most important French painter of the seventeenth century and the first painter from that nation to achieve international acclaim. All these facts deepened my respect for Poussin as an art historical figure. Yet even the stunning revelation that one of the world's foremost specialists in Poussin's art, the late British scholar Sir Anthony Blunt, had actually been a spy, has not made these paintings seem any more appealing to me.

The process of creating any work of art—whether superrealistic, totally abstract, or somewhere in between—involves making an enormous number of aesthetic decisions about even the most minute details. Professional artists are trained to deal with these subtle visual distinctions. However, even viewers with no formal background in art or design have immediate, strong, and highly personal responses to the same types of details—whether looking at a painting or deciding what clothes to put on in the morning.

> *"When you go out to paint, try to forget what objects you have before you—a tree, a house, a field, or whatever. Merely think, here is a little square of blue, here an oblong of pink, here a streak of yellow, and paint it just as it looks to you, the exact color and shape, until it gives your own naïve impression of the scene before you."*
> Claude Monet, as quoted by Lilla Cabot Perry, c. 1889

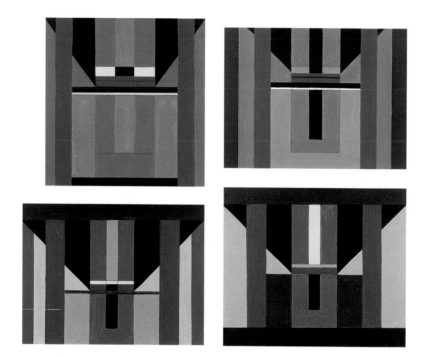

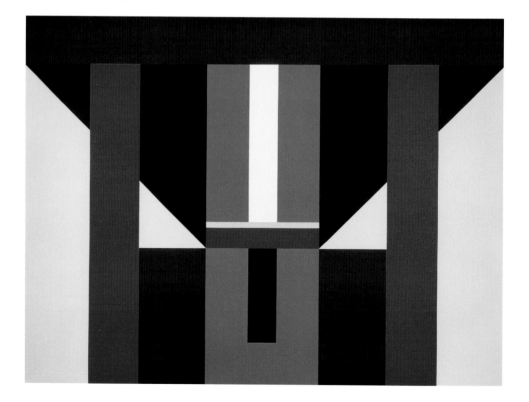

We have a rare opportunity to see, in detail, how one artist made some of these decisions, and to compare her aesthetic preferences with our own, by comparing four preparatory studies (plates 13–16) to the final work (plate 17)—all by the noted Colombian artist Fanny Sanín. For many years Sanín has specialized in a particularly rich form of geometric abstraction (i.e., nonrepresentational pictures made up of hard-edged forms such as rectangles and triangles). She is constantly experimenting with different colors, shapes, proportions, and arrangements. Sanín typically makes a number of small studies in acrylic on paper before painting her final canvases. Although each study has obvious ties to all the rest, every painting also displays its own distinctive "personality."

For example, Sanín's *Study 5 for Painting No. 2* and *Study 11 for Painting No. 2* feature heavy black bars placed horizontally across the top and/or bottom of the composition. These have the effect of framing the picture, making the rest of the elements seem to be located farther back within the illusionistic space. Spatial games such as this are an important part of Sanín's work; she deliberately keeps the relationships among her forms ambiguous, so that each viewer can interpret them in her own way. Since it has no strong horizontals, *Study 1 for Painting No. 2* reads more like a series of vertical stripes, interrupted—or tied together— by short, narrow strips of gray, rust brown, black, and white. The central green shape seems to float above the painting's base, and the whole composition is enlivened by a dramatic wedge of black that seems to come down from the very top of the picture. This black wedge is probably the most dynamic element in all of these paintings, since it introduces the only diagonals and also makes

OPPOSITE, TOP
13–16. Fanny Sanín (Colombian, born 1938), 1989. Acrylic and pencil on paper, 15 x 20 in. (38.1 x 50.8 cm) each. Collection of the artist. Left to right, top to bottom: 13. *Study 1 for Painting No. 2.* 14. *Study 2 for Painting No. 2.* 15. *Study 5 for Painting No. 2.* 16. *Study 11 for Painting No. 2.*

OPPOSITE, BOTTOM
17. Fanny Sanín, *Acrylic No. 2*, 1989. Acrylic on canvas, 56 x 72 in. (142.2 x 182.9 cm). Collection of the artist

us wonder what happened to its lower point. Is it hidden behind the other forms? Does it simply stop where the short horizontal bars seem to cut it off? Or is this black form not really a single wedge at all, but rather a series of smaller, discrete black shapes that only seem to be connected?

There are myriad other differences among the studies. All five use essentially the same colors, but *1*, *5*, and *11* have a much stronger contrast between the light shades of green and the darker black, gray, and brown forms, whereas *Study 2* and *Acrylic No. 2* are made up of far more similar values. All these pictures explore the relationship between a central, gray-green form and a series of narrower vertical and horizontal elements. Yet sometimes the central gray-green shape seems to rest on a horizontal bar, while at other times it floats or extends down to the lower edge of the painting. As a result of these and many other variations, each member of this five-part group makes a very different impression.

The subtle aesthetic distinctions demonstrated by Sanín's art can be seen even more clearly in a group of paintings by other artists, all of which feature a single formal element: the stripe. During the 1960s there was a vogue among avant-garde painters for so-called stripe paintings. One of the most celebrated of these artists was Gene Davis, who was noted for making enormous canvases covered from top to bottom with narrow multicolored stripes. It is easy enough to understand why some viewers have dismissed Davis's typical stripe paintings, like *Moondog* (plate 18), as "wallpaper," since it would, indeed, be simple to extend the stripes in all directions without materially altering his overall design. (On more than one occasion the artist actually did cover a museum's interior walls with his signature stripes, and the effect as you entered a space entirely defined by strips of color was exhilarating.[1]) People also tend to feel that, by choosing stripes as his sole motif, Davis was somehow cheating, as though painting colored stripes isn't sufficiently challenging—intellectually or technically—to be considered art. Still others have objected to the whole idea of creating a nonobjective painting on such a large scale (nearly

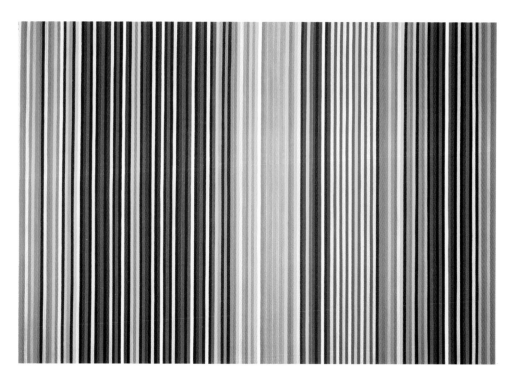

18. Gene Davis (American, 1920–1985), *Moondog*, 1965. Acrylic on canvas, 9 ft. 8 in. x 13 ft. 5 in. (2.9 x 4.1 m). Rose Art Museum, Brandeis University, Waltham, Massachusetts. Anonymous gift

"I'm interested in color to define intervals, in somewhat the same way a map maker uses color to differentiate between states or countries. It's for definition instead of decoration. When I make stripes in different colors, the purpose is to identify the interval. I'll put a red here on the right and, let us say, three feet away I will use another red. Now, that's going to define the interval between those two stripes in a way it would not do if I made this other stripe green, because then there would not be a dialogue established between those two stripes. When I make them both red, dialogue is established between them, and it defines this interval. My work is mainly about intervals, that is, like in music. Music is essentially time interval, and I'm interested in space interval."

Gene Davis, 1975

nine and a half by thirteen and a half feet), as though only a detailed, realistic, narrative image could justify the use of so much paint and canvas.[2]

Not everyone would enjoy spending time in a room painted by Gene Davis—this is where personal taste comes to the fore. Yet, whatever one may feel about his pictures, painting stripes is just as difficult as painting anything else. It might seem that once an artist has determined to use the stripe motif, his work is essentially done. Actually, that is only the beginning. Even the physical act of painting stripes like these is far more difficult than it may appear. Masking tape, rulers, and narrow brushes all help, but it still requires a great deal of skill, patience, and time to execute the kinds of precisely measured, crisp, hard-edged, large-scale, multicolored stripes for which Davis is known.

More to the point, the aesthetic choices required to make a painting such as *Moondog* are as numerous, and as challenging, as those Rembrandt faced in painting his portraits (see plate 47). First of all, Davis had to decide that he wanted these stripes to be vertically oriented. Then, innumerable related decisions had to be made: how tall should these stripes be, and how wide? Should they go right to all four edges of the canvas, or have some type of border? What colors—and which shades of those colors—should he use? And in what order should he place the various colors—since ultimately that order determines the visual rhythm of the painting?

Every artwork, even an apparently simple composition like this one, is essentially a mini-ecosystem. Therefore, just as in nature so in a stripe painting every change that is made, even the smallest alteration, changes everything else within the painting. To test this idea, imagine removing all the bright red stripes from *Moondog* and replacing them with white ones. Alternatively, imagine lightening the yellow stripes to a pastel shade, or changing the overall format of the canvas to a square. You might think these changes made *Moondog* a better painting, or a worse one, but either way their impact would be considerable.

At Davis's memorial exhibition (held at the Smithsonian

Institution's National Museum of American Art in 1987), the curators set up a clever demonstration, designed to convince skeptical visitors that there really was "art" involved in his pictures. Today the same point could be more efficiently made with a personal computer, but in those lower-tech days the staff made do with a group of bins, each containing multiple strips of different-colored, lightweight metal—like the slats from mini-blinds. One bin held only white strips, and there were other bins for the red slats, blue, yellow, green, and so forth. Two long magnets had been attached to the top and bottom of a nearby wall. The idea was that a museum visitor could choose several colored metal strips from the bins, stick them in neat vertical rows on the wall (where they would be held in place by the magnets), and then step back to admire her own version of a Gene Davis painting. Not surprisingly, it proved very difficult for visitors to create a sequence of stripes that they found pleasing—thus reinforcing a sense of respect for the process, at least, that Davis used to create his work.

True skeptics might still protest that when you've seen one stripe painting, you've essentially seen them all. In reality, despite their similar formats, Davis's various canvases look quite different from each other—and even more different, of course, from stripe paintings made by other artists. As noted above, even viewers with no artistic training respond—viscerally, reflexively, and differently—to the various colors, scales, visual rhythms, and moods of different stripe paintings. Take, for example, Kenneth Noland's *Graded Exposure* (plate 19). Although it is nonrepresentational, just because its stripes are oriented horizontally it suggests a landscape to some viewers. Noland chose different colors than Davis did, and most obviously, he varied the widths of his stripes—which tends to make the eye move more quickly over the upper part of the canvas, where the stripes are narrower.

Because they have such diverse aesthetic elements, even if you dislike both Davis's and Noland's paintings, you almost certainly will respond differently to them and to each of the other stripe paintings that follow. In *Onement, I,* by Barnett Newman

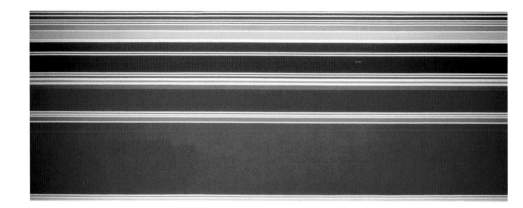

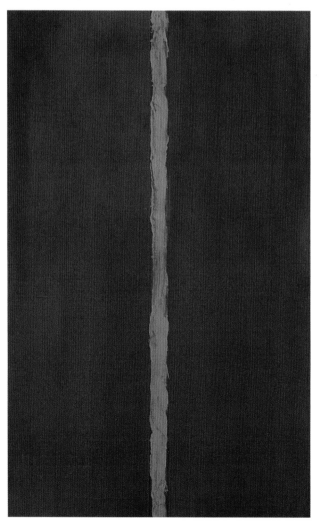

19. Kenneth Noland (American, born 1924), *Graded Exposure,* 1967. Acrylic on canvas, 7 ft. 5 in. x 9 ft. 1 in. (2.3 x 2.8 m). Courtesy of the artist

20. Barnett Newman (American, 1905–1970), *Onement, I,* 1948. Oil on canvas, 27¼ x 16¼ in. (69.2 x 41.2 cm). The Museum of Modern Art, New York. Gift of Annalee Newman

(plate 20), we have returned to the vertical stripe—or, as he called it, a "zip"—in this case, a single gold-colored stripe on a field of tomato red. Or we could instead consider this a three-stripe painting. Either way, this canvas feels quite different from either Davis's or Noland's. Instead of their series of clean, almost mechanically regular stripes, Newman focused on the single, painterly gold stripe with decidedly irregular edges that bisects the canvas.

The work by Brice Marden illustrated here (plate 21) is actually made up of four separate panels, though it is impossible to tell this from even the best-quality reproduction. Since the panels are placed side by side, it looks—both in photographs and in the original—like a single work made from four broad stripes of color. Marden's palette is reminiscent of Sanín's, but his composition certainly is not. Here, the principal visual interest lies in the way the widths of the stripes change from one panel to another, implying a sense of movement. In contrast to Marden's sequence of rectangles, in *Hamsa* (plate 22), the French Canadian artist Rita Letendre arranged a series of flat, brightly colored stripes around a central black V-form. In so doing, she produced a dynamic, intensely dramatic composition that stresses long diagonal lines and slices of rich color.[3]

Finally, Morris Louis created a series of stripe paintings using very thin pigment that he literally poured over his enormous canvases (plate 23). Louis's technique explains why the edges of these stripes bleed into one another and why there are

"I'm interested in the pulse of each color finding its place in relation to the pulses of other colors. It's like getting colors in accordance. There's no such thing as a bad color; it's just situated in some way that it's not all right or there's too much of it or there's too little of it. It's in the combinations. If you get that combination into a certain kind of focus, then that focus itself dictates the size and shape—or the size and shape will dictate a certain kind of focus—and will make any colors compatible."

Kenneth Noland, n.d.

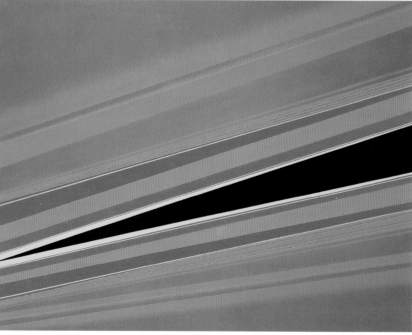

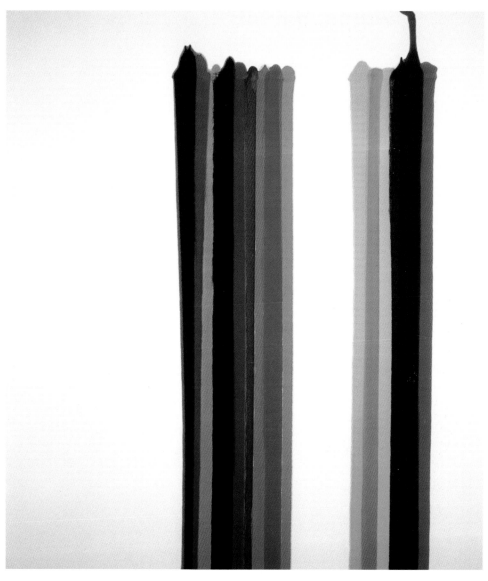

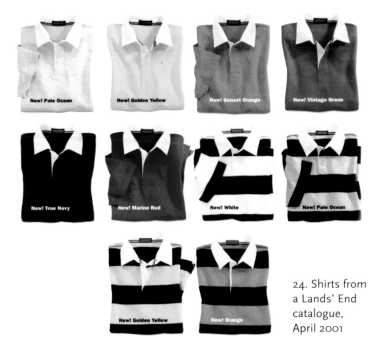

24. Shirts from
a Lands' End
catalogue,
April 2001

such prominent, irregular, dripped marks at one end of the stripes. But it is his decision to leave those drip marks as part of the finished painting, along with the expanses of unpainted, raw white canvas on either side of the multicolored column, that makes this such an intriguing picture.

Even though we are not all visual artists, virtually all of us make routine, often unconscious, aesthetic decisions that are closely related to those made by the painters discussed above. This is especially clear in terms of the way we choose our clothing and home decor. For example, clothing stores—and especially catalogue companies—stock a wide variety of short-sleeved cotton knit shirts, many of them featuring horizontal stripes (plate 24). Assuming that all the various striped shirts are the same price and that the right size is available in all possible color combinations, I would argue that people select one shirt over another by considering the same sorts of issues that led Gene Davis to choose the colors for his stripe paintings. Granted, the two situations are different—for one thing, the shirt manufacturer has already determined how wide the stripes will be, in

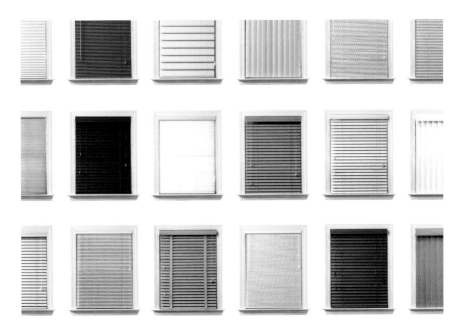

25. Advertisement for Next Day Blinds, May 2001

what direction they will be oriented, and which color combinations will be produced for a given season. (The closest parallel to Gene Davis would be the fashion designer who created the look of these shirts.) Nevertheless, the consumer still makes basic aesthetic decisions: do you prefer bright or pale colors? Should the color combination feature a strong contrast between very light and very dark colors, or do you prefer a subtler shirt, one in which the colors are closer in value? Some striped shirts make us look (or, at least, we *think* they make us look) taller or shorter, thinner or heavier; certain colors might accentuate a person's eyes, skin, or hair. Ultimately, a given shirt is likely to put one wearer into a good mood, while the same garment might make someone else feel intensely self-conscious or uncomfortable.

Similar, and sometimes even more subtle, aesthetic distinctions are involved in choosing an item of home decor, such as a set of window coverings. These days there are myriad options, including shades and blinds of every imaginable size, shape, material, color, and design. The advertisement reproduced here

(plate 25) is particularly appropriate for this chapter, since all the shades and blinds it illustrates are relatively similar, and neutral, in color—thereby providing us with an array of essentially monochrome (one-color) stripes from which to choose. As with abstract paintings or striped knit shirts, different shoppers will inevitably prefer different versions of these window coverings. Again, beyond price, size, and availability, these decisions are made on an aesthetic and highly personal basis. There is nothing inherently superior about a darker, versus a lighter, shade of blinds; horizontal rather than vertical slats or pleats; or a specific width of "stripe," whether regular, mini-, or micro-blinds. Yet just the fact that so many different possibilities exist clearly indicates that different consumers like different looks and will know what they like when they see it.

As difficult as it is for some viewers to accept the validity of Gene Davis's canvases as art, monochrome paintings (ones that consist entirely of a single color or of subtle variations on one color) encounter even more resistance, since they have no apparent content of any kind—no stylized horses, no multicolored grids, not even stripes. Monochrome paintings are probably the most challenging type of abstract art. No longer can the canvas be enjoyed as an imaginary window looking out onto nature, or even analyzed as a visually balanced, nonrepresentational composition. Instead, a monochrome painting is typically one large rectangle of color.

Why would anyone want to make such a work? For that matter, why would anyone want to look at it? People create, and contemplate, monochrome paintings for the same reason that they become fascinated with any other kind of visual art: because, in the end, *all* art is an arrangement of colors and shapes, which some (though not all) viewers find intriguing. Many people have strong feelings about colors, whether in the abstract or when buying cars, clothes, and mini-blinds. Visual artists, like other people, tend to favor certain hues and avoid the ones they dislike, but some painters become so fascinated with a particular color that merely using it to anchor a polychrome composition is not enough. Instead, they devote entire

26. Brice Marden, *Grove Group I,* 1972. Oil and wax on canvas, 6 x 9 ft. (1.8 x 2.7 m). The Museum of Modern Art, New York

canvases—or series of canvases—to exploring variations on that color.

With *Grove Group I* (plate 26), Brice Marden decided to create a gray-green rectangle, so large (six feet by nine) that it becomes not merely a patch of color hanging on a wall but the wall itself.[4] In other words, while we are looking at it, the painting becomes our environment, filling our field of vision with the particular hue the artist has chosen. Of course, the viewer is free to like, dislike, or feel neutral about this color—or the whole idea of an enormous monochromatic rectangle. Still, it may be useful to know that Marden's painting is an example of the movement known as Minimalism, which evolved during the late 1950s and 1960s among avant-garde artists (such as Donald Judd, Yves Klein, Agnes Martin, Ad Reinhardt, and Tony Smith) whose paintings and sculptures employed the minimum number of elements necessary to make works of art.[5] These works typically consist of one or just a few colors

27. Shirley Goldfarb (American, 1925–1980), *Yellow Painting No. 1*, 1967. Oil on canvas, 6 ft. 5 in. x 9 ft. 10 in. (2 x 3 m). Collection of Mark Rudkin, Paris

and shapes, often repeated several times. Many viewers find this approach to art puzzling, since it features none of the things we tend to expect to find within artworks. However, in its broader historical context, such art makes sense: Minimalism was largely a self-conscious rejection by a group of young artists of what they perceived as the emotional excesses of the Abstract Expressionists, who had dominated the avant-garde art world of the previous decade. Therefore, if the canvases painted by Jackson Pollock, Franz Kline, and Willem de Kooning (like the sculptures of Herbert Ferber, Ibram Lassaw, and their other contemporaries) had multicolored, irregular, action-filled surfaces and compositions, then the work made by many of their successors would be monochrome and nonpainterly.

Even the most expert reproductions can give only a partial sense of the presence of any artwork. It is obvious why a sculpture is difficult to capture in two dimensions. But something important is lost, too, in the translation of a painting to the

printed page. This is especially problematic for Minimalist, monochrome canvases, in which the smallest variations of color and texture are absolutely critical. Most of the time, what the reader sees in a book illustration of a Minimalist painting is a flat, unmodulated, relatively uninteresting rectangle that gives precious little sense of the visual excitement of the original. In choosing the illustrations for this book, I decided not to reproduce one of the groundbreaking black-on-black canvases painted by Ad Reinhardt or an all-blue Yves Klein painting, because I had never seen a reproduction that did them justice. Illustrations of these works seem unable even to hint at the complex geometric patterns that underly Reinhardt's paintings or the subtle irregularities within Klein's.

Likewise, it is nearly impossible to capture in reproduction the small variations in surface texture formed, in Marden's picture, by the combination of oil paint, wax, and the weave of the canvas. In order to get the full impact of any artwork, you need to see the original—not as a slide in a lecture hall or an illustration on a page. This is especially true for monochrome paintings (or Minimalist sculptures). And this kind of art also demands more time than the three seconds the average gallery or museum visitor typically allots to each work. To form an adequate opinion about a painting like *Grove Group I*, you really need to sit or stand quietly in front of it for several minutes at least.

Reproductions of works by Shirley Goldfarb, an American painter who spent most of her adult life in Paris, sometimes give a hint of the varied hues and brush strokes with which she covered enormous canvases such as *Yellow Painting No. 1* (plate 27). However, it is impossible to convey the powerful effect of encountering such a large mass of vivid yellow in the original. Also, no reproduction can capture how thick some of these colored patches within the painting really are or suggest the complex patterns of shadows and highlights created on the surface as the light catches those patches. In addition to the obvious color differences, Goldfarb's monochrome painting has a much more active surface, with a busier, faster visual rhythm, than Marden's.

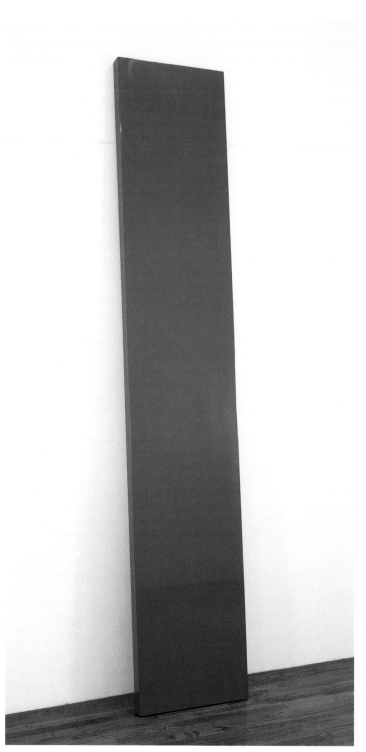

28. John McCracken (American, born 1934), *Flight*, 1995. Resin, fiberglass, and plywood, 114 x 20½ x 2½ in. (289.6 x 52.1 x 6.4 cm). Courtesy of the artist and David Zwirner, New York

In contrast to Goldfarb's art, the monochrome works by the sculptor John McCracken resemble their photographs much more closely because these sculptures feature just one shade of a given color and have perfectly smooth, glossy surfaces (plate 28). McCracken intentionally uses nontraditional sculptural materials and techniques, so his polyresin-and-fiberglass-covered plywood rectangle appears to have been produced by a machine rather than a human being. At the same time, leaning against the museum's wall rather than standing upright on a traditional pedestal or resting horizontally along the floor, McCracken's work calls to mind one piece of a child's bunk bed that someone has accidentally left behind. The allover color and hard, shiny texture of McCracken's leaning plank clearly owe a lot to California car culture (the artist was born in Berkeley and lived for many years in Los Angeles). He is obviously in love with the deep, rich, sensual surfaces of these sculptures, which work very well purely as abstract, geometric forms. However, McCracken has also noted that he leans his works to make them seem more "active." Moreover, he observes that these sculptures "touch two worlds," both the physical (the floor we walk on) and the mental (the wall, where paintings hang and "into" which we tend to gaze).[6]

The sculptures of Anne Truitt represent yet another variation on one-color Minimalism. Although they seem monochrome and simple in form, in fact her works typically incorporate a surprising number of variations, in both color and form. These are virtually undetectable in photographs and sometimes difficult to discern, at first, even in the original. For example, Truitt's *17th Summer* (plate 29)

> "I make real, physical forms, but they're made out of color, which as a quality is at the outset abstract. I try to use color as if it were a material; I make a sculpture out of, say, 'red' or 'blue.' Color is also sensuous. I felt right from the first that while I wanted to make very pared-down forms, I wanted them to be sensuous and beautiful so that they would be, and keep on being, interesting to look at."
>
> John McCracken, 1998

has a great many superficial similarities with McCracken's piece: both are abstract; both are essentially rectangular, both are made of wood, and both stress a single light-infused color. But their other qualities are quite different, and therefore they have a different impact, both visually and emotionally. Like much of Truitt's sculpture, this work is a hollow, freestanding wooden column, a form that can evoke all sorts of architectural and other associations.[7] Many of Truitt's works also have auto-biographical content, often related to her memories of growing up on Maryland's Eastern Shore. There is no way a viewer could intuit that meaning simply from looking at the sculpture. Nevertheless, both the name and the general appearance of *17th Summer* do seem to suggest something about the artist's past, whereas McCracken's title makes a rather general reference to motion. Although her sculpture is highly abstract, Truitt has said, "My work is totally referential. I've struggled all my life to get maximum meaning in the simplest possible form."[8] Yet she seldom explains exactly what that "meaning" might be, preferring—as many artists do—to let viewers form their own interpretations of her work. Although Truitt dislikes talking about the titles of her works, she has said that *17th Summer* refers to the seventeenth summer of her second daughter, Mary (b. 1958).[9]

Truitt's choice of the height, width, and overall

"When I painted a chair recently, I noticed that I put the paint on indifferently, smoothly but without particular attention. The results were satisfactory but not in any sense beautiful. Does the attention in itself with which paint is applied in art actually change the effect of the paint? Does the kind of consciousness with which we act determine the quality of our actions? It would follow, if this were true, that the higher the degree of consciousness, the higher the quality of the art. I think it likely. Training in art is, then, a demand that students increase the consciousness with which they employ techniques that are, in themselves, ordinary."

Anne Truitt, 3 February 1975

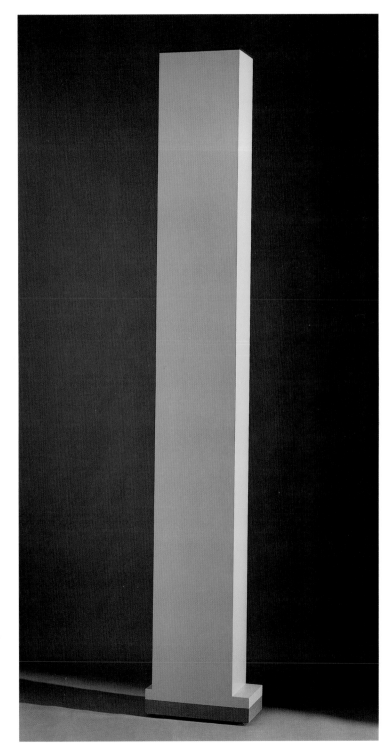

29. Anne Truitt
(American, born
1921), *17th Summer,*
1974. Painted wood,
95⅝ x 15⅝ x 8⅛ in.
(242.8 x 39.6 x 20.6
cm). Smithsonian
American Art
Museum, Washing-
ton, D.C. Gift of
Kenneth Noland

proportions of her sculpture makes an enormous difference in the final work, as does the light green color with which she has covered the column.[10] However, the most interesting aspects of Truitt's work are the unexpected, subtle variations she introduces. Sometimes she makes the tops of her wooden forms slightly wider than their shafts; other times, she slightly narrows just the bottom inch or so, toward the base; this can make the column appear to float above the floor. In *17th Summer*, Truitt has left the column the same size all around, except for its base; there the form suddenly flares out, forming its own narrow, two-tone, horizontally striped "pedestal," which seems awfully small to support this miniature monolith. Because the lower half of the pedestal is painted a neutral blue gray, it seems to disappear into the floor, again creating the illusion that the sculpture is suspended in midair.

Yet another variation on this theme—of vertically oriented, light-colored architectural forms—is the mysterious sculpture by James Lee Byars called *The Figure of Question* (plate 30). This tall, massive form calls to mind a column from some ancient temple in the Aegean—especially when you know that it is actually a solid piece of white marble. The artist has done two unexpected things to this sculpture: rounding all of its corners and covering the entire surface with gold leaf. As a result, Byars's column gleams and glows, especially when the sun comes through the glass wall next to which it is displayed. It is unusual, especially for a sculptor working in the 1980s, to fashion something out of a material as venerable, expensive, and challenging as marble—and then cover it up. Also, gilding—though not unheard of in recent decades—is certainly more commonly associated with sculptures from centuries past. With its gold exterior and impressive size, Byars's sculpture also suggests some sort of religious icon, though at the same time its provocative title appears to indicate that there can be no one correct interpretation of this work. This is another case in which reproductions mislead, giving the impression that the work has a totally smooth, polished, unmodulated surface. In fact, a thorough examination of the original work reveals

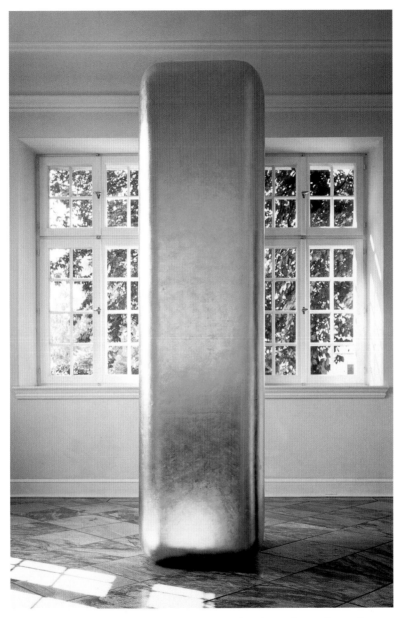

30. James Lee Byars (American, 1932–1997), *The Figure of Question,* 1989. Marble and gold leaf, 8 ft. 8 in. x 2 ft. 2 in. x 2 ft. 2 in. (2.6 x 0.6 x 0.6 m). The Baltimore Museum of Art. Purchase with exchange funds from Bequest of Mabel Garrison Siemonn, in Memory of her Husband, George; Bequest of Blanche Adler; Gift of Thomas A. Leahy, Bronxville, New York; Gift of the Living Arts Foundation, Inc.; and Gift from the Estate of Felicia Meyer Marsh, BMA 1990.117

numerous tiny irregularities that make the light bounce around the surface, causing Byars's sculpture to sparkle.

Despite all their subtleties, it is easy to see why mono-chrome, Minimalist works like those by Byars, Goldfarb, Marden, McCracken, and Truitt have long been popular targets for comedic actors, writers, and even some other visual artists. When the humorist Dave Barry wanted to poke fun at the incompre-hensible nature of much publicly funded sculpture, he chose to describe a generic example of Minimalism.[11] But the best artistic target of all—for comic-strip artists, satirical writers, and late-night comedians alike—has long been the mother of all minimalist, monochrome artworks: the white-on-white paint-ing (literally, a white canvas covered with white paint).

As difficult as it may be to deal comfortably with a six-by-nine-foot gray-green-painted rectangle, at least in that case it is clear that the artist actually *did* something. A true white-on-white painting, however—typically a large rectangular can-vas—inevitably reminds one of a whole host of sophomoric jokes ("What does it represent? A polar bear eating marshmal-lows in a snowstorm!"), and forces the viewer to question how buying the painting would be any different from going out and acquiring a plain prestretched and gessoed canvas (the thing painters generally start out with), or simply staring at a blank white wall. No one likes to feel foolish about art, and there is nothing like a white-on-white painting to make people feel foolish. Printed reproductions generally make matters worse, since photographic images of white-on-white paintings tend to look like blank book pages. I must confess that, before I saw a number of his works exhibited together, I was not especially impressed by the art of Robert Ryman, an American painter known since the late 1960s as one of the foremost practitioners of white-on-white painting. Ryman is still not one of my favorite artists, but having seen his 1993 retrospective at New York's Museum of Modern Art I can now appreciate, far more fully, the technical skill and the fertile imagination that he brings to his work (plate 31).

31. Robert Ryman (American, born 1930), *State*, 1978. Oil on cotton with metal, 88 x 84 in. (223.5 x 213.4 cm). Albright-Knox Art Gallery, Buffalo. George B. and Jenny R. Mathews Fund, 1979

Ryman's paintings are what every abstract artwork is: an arrangement of colors (or, in this case, shades of a single color), textures, and forms. Although this is almost never visible in reproductions, in fact Ryman does vary these aesthetic elements, sometimes quite a bit, in his white-on-white paintings. Some have areas of very thick paint, contrasted with thinly painted, or even unpainted, sections of canvas. Others incorporate mixed media (mainly staples and bits of masking tape—all covered, to one degree or another, with white paint) into the composition. Most, but not all, are symmetrical. Indeed, the most interesting thing about Ryman's work is the seemingly limitless number of tiny variations—on a limited number of visual themes—that it explores. Ryman is perhaps the most persevering of a long line of painters who have experimented with all-white canvases. As early as 1918 the Russian painter Kasimir Malevich created a work consisting entirely of one white square placed, at an angle, atop a larger white square. Other artists, such as Sam Francis and Robert Rauschenberg, began producing monochrome white paintings around 1950, and during the late 1930s Ben Nicholson made a series of white-on-white "relief paintings," in which the rectangles projected outward from the main support. Thus Ryman is part of a venerable tradition, albeit one that many viewers still find it difficult to accept.

Ryman was one of the artists skewered during an infamous segment of the popular CBS television news magazine *60 Minutes* that aired on 19 September 1993.[12] At one point the reporter, Morley Safer, interviewed a collector who seemed somewhat foolish as she repeated a phrase that she clearly had been taught about the white-on-white painting by Ryman that was hanging in her apartment. The woman said something about the artist's having "reduced painting to its very essence," and Safer—struggling to keep a straight face—agreed; the segment then moved on to disparage another abstract artwork. Although this encounter was filmed more than eighty years after such paintings had become part of modern art history, white-on-white paintings have remained an easy target. They are still popular subjects for countless comic strips, *New Yorker*

cartoons, television advertisements, and even a recent Pulitzer Prize-winning play,[13] all implying that such a canvas can only be the result of "painter's block" or some sort of "emperor's new clothes" scam being run by a fast-talking fraud.

One way to appreciate more fully the work of someone like Ryman is by considering the process involved in painting the inside of your house white. Few experiences are as frustrating as going to the paint store and trying to decide exactly which shade of white paint to buy. It can be

Ice Ballet
30RB 73/016

Blush
80YR 75/057

Opal
30YY 79/053

Woodwind
20YY 74/055

Antique White
40YY 83/043

Wedding White
70YY 83/037

Navajo White
40YY 69/112

Pure White*
00NN 92/000

32. Paint chips in various shades of white. Courtesy of The Glidden Company

extraordinarily difficult even to *see* the differences among the myriad paint chips called "white" (plate 32), let alone decide which one will look best in the living room. After careful consideration, it becomes evident that some shades of white actually have a decidedly blue, gray, yellow, or even lavender cast. There is also the question of the surface quality of the paint. Most colors come in matte, semigloss, and gloss versions, each of which gives a very different effect. Eventually we do choose a shade—or several shades—of white paint to live with. Since we are all capable of making such subtle aesthetic discriminations, and since abstraction is now nearly a century old, it would be helpful if we could apply those same skills in looking at, and thinking about, abstract, monochromatic art.

33. Georges Braque (French,
1882–1963), *Landscape at La Ciotat,*
summer 1907. Oil on canvas,
28¼ x 23⅜ in. (71.7 x 59.4 cm). The
Museum of Modern Art, New York.
Acquired through the Katherine S.
Dreier and Adele R. Levy Bequests

PAINTINGS THAT PEOPLE LOVE TO HATE

4

"What we see here has nothing to do with painting. Formless streaks of blue, red, yellow, and green, all mixed up, splashes of raw color juxtaposed without rhyme or reason, the naïve and brutal efforts of a child playing with its paintbox. . . . [This art,] by our standards at least, is either raving madness or a bad joke."

Marcel Nicolle, 20 November 1905

THE QUOTE CITED ABOVE is typical of the comments made by French journalists in response to a group of radically new paintings exhibited in the infamous Room 7 of the 1905 Salon d'Automne (one of the most important exhibitions of art held in Paris). Although the painting by Georges Braque illustrated in plate 33 was not actually part of that Salon, it is very similar to the works that caused a famous scandal and led to the designation of such art by the French word *fauve*, meaning "wild

beasts."[1] There are various stories about why Fauve was applied to this group of painters, but there is no doubt that the word was meant as an insult.

Actually, considering the expectations still held about works of art by most people in western Europe and the United States in 1905, Marcel Nicolle was correct. In Braque's landscape, as in all typically Fauve canvases, the bright colors do seem almost raw, as though they had come straight from the tube. Moreover, they undoubtedly seemed even brighter to contemporary audiences than they do to us today, given our familiarity with acrylic paint and Day-Glo neon colors. The French critic also had a point when he noted the "formless," irrational aspects of the paintings. Even if Braque made this painting during the autumn, when real landscapes can be remarkably colorful, these exact colors could not have existed where he placed them. Instead, he was making a conscious break from the centuries-old tradition of depicting nature as it really is in favor of applying his colors where and how he wanted.

"One must not imitate what one wants to create. . . . To work from nature is to improvise."

Georges Braque, 1917

Nicolle was fundamentally correct when he claimed that this kind of work had nothing to do with painting (as he defined it). However, he was dead wrong in asserting that this picture looked as though it had been created by a child (more on this topic later). Also, Braque was a serious, academically trained artist who devoted his life to art, and his early Fauve paintings were definitely not intended as a joke. The most interesting thing about Nicolle's comment is its universality. Critics writing about avant-garde art in the years before Fauvism had said almost exactly the same things about Impressionism. Likewise, critics today still tend to disparage unconventional new art, in terms that are nearly identical to those used by Nicolle a century ago.

Although it is now one of the most beloved, and most valuable, types of art in the Western world, in its heyday (the 1870s and 1880s) Impressionism was simply another avant-

34. Claude Monet (French, 1840–1926), *Boulevard des Capucines*, 1873–74.
Oil on canvas, 31⅝ x 23¾ in. (80.3 x 60.3 cm). The Nelson-Atkins Museum
of Art, Kansas City, Missouri. Purchased by the Kenneth A. and Helen F.
Spencer Foundation Acquisition Fund, F72-35

garde approach and was generally excoriated by members of the
art world. One famous example is the critical response to Claude
Monet's *Boulevard des Capucines* (plate 34). Most reviewers at the
time regarded it as a terrible painting—and said so. One of their
principal objections concerned what they perceived as its slop-
piness—and, indeed, compared to the scrupulously detailed,

realistic, tightly painted canvases that art reviewers (and the art-viewing public) had been trained to expect (see, for example, plate 85), this *is* sloppy. The broad, brushy strokes of paint merely suggest the impression of trees, buildings, and passersby, as viewed from an upper-story Paris window. Of course, Monet—who had been thoroughly trained in traditional techniques—had deliberately chosen to work this way, specifically in order to create the effect of a quick glance out the window rather than a carefully studied catalogue of everything one might see while contemplating that view for several hours.

Contemporary critics were particularly upset by the lower right-hand section of the painting. One writer famously inquired, "What are those innumerable black tongue-lickings?"[2] which today we easily recognize as men and women strolling along the boulevard. However, late-nineteenth-century viewers were not used to looking at movies, television, and other inventions that have significantly altered the way we now process visual perceptions. And even today a tight close-up of this part of Monet's canvas would be difficult for anyone to decipher, since those smudges do not, in fact, resemble people. As with Fauvism thirty years later, the Impressionist approach to painting was (incorrectly) compared to the work of children or the insane; its use of highly saturated color (not as evident in this rather subdued illustration as in other examples from the same time) was also criticized. Even its basic identity as art was questioned, by critics indulging in the easiest, and most meaningless, way to dismiss a type of art they found offensive.

It was similarly dismissive of Nicolle to say that the Fauve pictures in that 1905 exhibition looked like child's play. At the time, no one was willing to grant children's drawings, paintings, and sculptures any status as "art." However—thanks to the explorations of artists and art dealers such as Pablo Picasso, Alfred Stieglitz, and many other early modernists who were willing to stretch traditional boundaries—that attitude has long since changed. And though not every youthful daub displayed on the family refrigerator belongs in a museum, today more

people—both inside and outside the art world—have gotten interested in the art made by all sorts of individuals, of whatever age and with whatever degree of training.

Value judgments aside, children's art simply does not look the same as even highly stylized art produced by grownups. Look, for example, at Joan Miró's *Portrait of E. C. Ricart* (plate 35). At this early point in his career Miró was clearly being influenced by several radical approaches to painting, including Fauvism, and also—as seen from the Japanese print glued to the right-hand side of the canvas—by a continuing interest in Asian art.

It is easy to see why some viewers—whether in 1917 or 2002—might find the painting objectionable, since Ricart's actual face was obviously not made up of patches of green, rose, and mustard, nor was his hair dyed in the wild colors that a young art student might favor today. In addition to intentionally distorting Ricart's hands and flattening out the stripes in his shirt, Miró grossly exaggerated Ricart's facial features; for example, the eyes are simply outlined in black paint, with multicolored lines and more black lines indicating bags underneath them. Similarly, the ears seem to be set on Ricart's head at totally different angles; they are also curiously uneven. Indeed, this is a sort of caricature of the man (Miró's friend, and a fellow Catalan painter), not a conventional portrait.

However, if we compare Miró's painting to a portrait drawing by a child (plate 36), both the similarities and the differences become clear. Like Miró, this youthful artist also took liberties with anatomy, leaving out entire body parts (notably the chin) and grossly simplifying the structures and appearances of facial features. However, it seems a safe bet that Ricart could be identified from Miró's admittedly altered portrait, but it would be difficult, if not impossible, to recognize the actual subject of the child's picture. Even though it contains prominent features that could be useful clues (a particular hair color or style, bushy eyebrows, etc.), it is far more generic than Miró's portrait.

ABOVE

35. Joan Miró (Spanish, 1893–1983),
Portrait of E. C. Ricart, 1917.
Oil and pasted paper on canvas,
32⅛ x 25⅞ in. (81.6 x 65.7 cm). The
Museum of Modern Art, New York.
Florene May Schoenborn Bequest

OPPOSITE, TOP

36. Child's drawing, *Portrait*,
c. 1948. Gouache on paper, 12⅜ x
9⅝ in. (31.3 x 24.5 cm). Collection
de l'Art Brut, Lausanne, Switzerland

OPPOSITE, BOTTOM

37. Ed Frascino, cartoon from the
New Yorker, 21 November 1988

*"Mrs. Hammond! I'd know you anywhere from
little Billy's portrait of you."*

Likewise, as simplified as the figure paintings and drawings by the French artist Henri Matisse (one of the original Fauve painters) can sometimes be, they are clearly not the work of a child. The black chalk drawing by Matisse reproduced as plate 38 consists of just a few slender lines that seem to have been laid down quite rapidly. In this work, Matisse was obviously not attempting to create a believable sense of either anatomy or space, since he eliminated the figure's nostrils and ears as well as any indication of a background, modeling, or the rest of the woman's body. Almost nothing *is* there, except some black-and-white curves, but the artist managed to say everything he needed to by using just those curves. As in his more fully developed works, here Matisse conveys an enormous amount of information with a startling economy of means. The child artist provided more specific details, but Matisse's shorthand view of this woman reveals a sophisticated awareness of composition in the way he balanced her head—set toward the right side of the sheet of paper—with her voluminous, wavy hair, suggested by a simple, curving line. This woman might, or might not, have been recognizable from her "portrait," but she certainly seems appealing, since Matisse has given her a sense of warmth, humor, and sensuality.

Contemporary critics, and viewers, of avant-garde art from the late nineteenth and early twentieth centuries typically complained that the work seemed sloppy, irrational, childish, or insane. These very same criticisms have frequently been directed at nontraditional art from the late twentieth and early twenty-first centuries. However, all the examples mentioned above deal mainly with the physical appearance of the works in question. And, although that is obviously one of the most important aspects of what is, after all, known as *visual* art, it is by no means the only element that matters to viewers. During the last half-century in particular, a surprising amount of verbiage—in art journals and popular magazines alike—has been devoted to criticizing not just

> "Abstract art is a product of the untalented, sold by the unprincipled to the utterly bewildered."
>
> Al Capp, *National Observer*, 1 July 1963

38. Henri Matisse (French, 1869–1954), *Head of a Woman*, 1948. Black chalk on green laid paper, 18⅞ x 12⅜ in. (48 x 31.5 cm). Art Gallery of Ontario, Toronto. Gift of Mrs. Nora E. Vaughan, 1987

how recent works of avant-garde art look but also how they were made.

Artists in the Western world have been using essentially the same techniques for many centuries. Painters, in particular, have long quoted with approval Leonardo da Vinci's comments

(see sidebar, page 74) that the process of painting was superior to that of sculpture because it could be done while wearing one's best clothes, listening to music (or soothing poetry), while seated before an easel.[3] Another point in painting's favor, for Leonardo, was the fact that painters manipulated pigments—using a palette and an assortment of sable brushes—on the beautifully smooth, flat surface of a previously prepared canvas. (These materials would all have been prepared by studio assistants.) Modern artists, especially the more nontraditional ones, seldom dress up to spend the day in the studio. But today, as in the 1400s, for the vast majority of painters—whether realist or minimalist—the usual method of painting remains substantially unchanged. Acrylics may be used instead of oil, and the background sounds may come from a CD rather than live music. Still, a Renaissance artist confronted with a typical twenty-first-century studio would have no trouble understanding what the modern painter was doing.

"The sculptor's face is . . . powdered with marble dust, so that he looks like a baker. . . . His house is dirty and filled with chips and dust of stones. . . . [Whereas,] the well-dressed painter sits at great ease in front of his work, and moves a very light brush, which bears attractive colors. . . . His dwelling is . . . clean and often filled with music, or the sound of beautiful works being read, which are often heard with great pleasure, unmixed with the pounding of hammers."

Leonardo da Vinci,
Treatise on Painting, n.d.

The methods of certain other artists from the last half-century might, however, be more perplexing. The most notorious case of a painter whose unconventional technique regularly overshadowed his actual painting is the American Abstract Expressionist pioneer Jackson Pollock. As noted in chapter 2, and as re-created quite convincingly in the feature film *Pollock,*[4] Pollock made his signature poured paintings (like the one illustrated as plate 7) by subverting the processes that Leonardo and countless other painters had painstakingly perfected.

Because he "wanted to be inside" his paintings, from 1947 until his death a decade later Pollock typically avoided both easels and stretcher strips. Instead, he unrolled huge lengths of raw canvas (since canvas is simply a kind of cloth, this was like unrolling a bolt of wool or silk) on the floor of his barn-like studio in East Hampton, New York. Then Pollock liter-ally flung paint (and some-times also dropped bits of plastic, metal springs, or even cigarette butts) onto the can-vas as he danced all around it, using brushes, sticks, pierced metal cans, his fingers, or anything else he wanted to add color to the picture (plate 39). This was hardly a calm, Renaissance-style way of putting a painting together. It also wasn't neat; Pollock inevitably got paint all over his clothes, the floor, and everything else in range.

> "My painting does not come from the easel. I hardly ever stretch my canvas before painting. I prefer to tack the unstretched canvas to . . . the floor. I need the resistance of a hard surface. On the floor I am more at ease. I feel nearer, more a part of the painting, since this way I can walk around it, work from the four sides and literally be 'in' the painting."
>
> Jackson Pollock, 1947

The early reviews of Pollock's dripped and poured paint-ings were largely negative, though several influential writers recognized a spark of something important in his work. Yet in 1949—two years after he had begun making his signature works—Pollock was featured in a *Life* magazine article that asked if he was "the greatest living painter in the United States?"[5] This rhetorical—and deliberately inflammatory—question greatly increased the public's curiosity about the artist, whose celebrity status remains undiminished today.

Much of the initial criticism focused on the fact that Pol-lock's pictures were so large and so incomprehensible, since they lacked identifiable subjects. However, as the voluminous literature published about Pollock during the early 1950s makes clear, what really shocked most viewers and often led them to dismiss Pollock's work entirely was the unorthodox way he

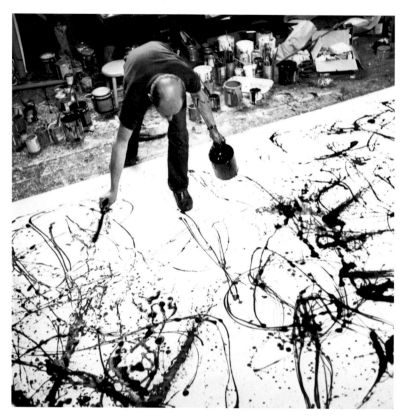

39. Jackson Pollock painting *Autumn Rhythm: Number 30, 1950* in his studio, 1950. Photograph by Hans Namuth. Pollock-Krasner House and Study Center, East Hampton, New York

created these pieces. It is hardly surprising that Pollock's "drip" technique was lambasted during the 1940s and 1950s. But it is both unexpected and discouraging to discover—as I have done in many art history classes—that a lot of today's students, including art students, remain profoundly suspicious of Pollock's way of making art. I always urge them to try dripping paint onto a canvas—or even just a piece of paper—that has been placed on the floor. This quickly demonstrates that creating Pollock-like compositions is not nearly as easy as it looks. Young museumgoers sometimes find this point easier to grasp than some of their elders (see sidebar).

Over the years Jackson Pollock's name—and his dripped

and poured paintings—has inspired more art-based jokes, cartoons, comic strips, greeting cards, and advertisements than that of just about any other painter. But he is certainly not the only American artist to experiment seriously with alternative methods of applying color to canvas, and even the most basic physical characteristics of visual art have been challenged in recent decades. Today, paintings are no longer required to be stretched, framed, and hung on a wall. Although Rembrandt might have some doubts about this method, for many years now avant-garde painters have been working on unstretched canvases, as Pollock first began doing in the late 1940s. Subsequent generations of artists have taken the idea much further, exploring new ways of making paintings and also of displaying them.

"A 6-year-old boy, visiting the Pollock exhibition with his mother, was [impressed]. . . . His mother asked if he thought he could do something like it. 'Oh no,' he said, 'it's much too hard.'"

Flora Lewis, "Two Paris Shows à la Pollock," *New York Times*, 3 October 1979

In the late 1960s Sam Gilliam began producing enormous, brilliantly colored abstract paintings that are designed to be suspended from hooks in the ceiling or walls (plate 40). Because the canvases have not been pulled taut around wooden stretchers (the traditional method), their visual rhythms can vary considerably, depending not only on the colors and forms painted onto the canvas but also the curving shapes created by folds in the canvas itself.

Many recent works by Janine Antoni have also involved painting in unorthodox ways. Her 1992 work *Loving Care* (plate 41) is an example of what is typically referred to as a "performance piece" (because the process of creating this temporary artwork was the most important aspect of it).[6] For this performance at the Anthony d'Offay Gallery in London, Antoni—a young woman with long, dark hair—first stuck her head into a bucket of Loving Care–brand hair dye, then knelt down and made a series of rhythmic, curving, colored marks on the gallery's floor by bending forward and using her hair as a brush. Antoni's

40. Sam Gilliam (American, born 1933), *Light Depth*, 1969. Acrylic on canvas, 10 x 75 ft. (actual size of canvas) (3 x 22.9 m). The Corcoran Gallery of Art, Washington, D.C. Museum purchase 1970.9

technique was obviously intended to cause controversy, and indeed some people remain unsure that this piece constitutes art. However, one could argue that Antoni was simply using a variation on the traditional painter's tool—after all, a sable brush (the kind preferred by many artists, for centuries) is in fact made from a mammal's hair. Moreover, her use of the gallery's floor as her "canvas" could be seen as a logical extension of Pollock's technique.

The French artist Yves Klein also challenged traditional ideas about painting technique. Klein clearly relished coming up with ever more outrageous methods of producing his paintings, and you cannot always tell simply from looking at them how his large, and largely abstract, canvases were created. In terms of both technique and later influence, one of his most important series was *Anthropométries*—abstract forms made of

41. Janine Antoni (American, born 1964), *Loving Care,* performance at the Anthony d'Offay Gallery, London, 1992. Courtesy of the artist and Luhring Augustine, New York

a distinctive electric blue color (which he patented as International Klein Blue) juxtaposed against bare sections of white canvas. These were created, in true 1960s fashion, by a method combining nudity, voyeurism, "action painting" (another name for Abstract Expressionism, usually referring to the gestures made by the artist's arm when applying the paint), and what today would be called performance art. One of these "action-spectacles," as they were sometimes called, took place 9 March 1960, at the Galerie Internationale d'Art Contemporain, in Paris (plate 42). For this extravaganza Klein assembled one-hundred spectators, who sat and watched for forty minutes as a string orchestra played and three nude female fashion models "painted," by imprinting the huge sheets of paper that had been arranged on the gallery floor with their torsos, which had been smeared with International Klein Blue paint.

42. Yves Klein (French, 1928–1962), *Anthropométries of the Blue Age,* perform-
ance at the Galerie Internationale d'Art Contemporain, Paris, 9 March 1960

A surprising number of modern painters have utilized
rifles as their principal tools for painting. One of the best-known
exponents of this particular technique is the French-born Niki
de Saint Phalle, who made a name for herself during the 1960s
by shooting balloons filled with colored paint, arranged so that
they would explode and drop their contents onto prepared can-
vases placed beneath them. Some younger artists have followed
Klein's and Saint Phalle's lead in using unorthodox materials
and techniques. To cite just two recent examples, in the fall of
2001 E. V. Day suspended several hundred pieces of women's
underwear (thongs and G-strings) within the sculpture court of
New York's Philip Morris Building. And Ghada Amer made a
series of sculptures by covering boxes with slipcovers on which

she had embroidered excerpts from the text of an eleventh-century Muslim encyclopedia of sex. Like the other artists cited in this chapter, both these women obviously knew that their work would generally be perceived as inflammatory. However, Day and Amer were also working squarely within the tradition of the avant-garde, making art that encourages viewers to reconsider accepted ideas about sexuality, sculpture, and space, among many other subjects.

One of the most controversial annual events in the international art world is the awarding of the Turner Prize, a cash prize of £20,000 given annually to the best British artist under the age of fifty. In 2001 the prize went to Martin Creed, for his installation entitled *The Lights Going On and Off*, an empty gallery with a pair of lights timed to go on and off every five seconds. The artist refused to explain his work, commenting, "I think people can make of it what they like"; many prominent cultural critics clearly didn't think much of it. The playwright Tom Stoppard was offended by the fact that Creed hadn't fabricated any part of the work, stating, "The term artist isn't intelligible to me if it doesn't entail making." Others took issue with the idea of this as a profound Minimalist work. David Lee, editor of the satirical art journal the *Jackdaw*, said, "Last year, the Tate [the museum that sponsors the Turner Prize] was scraping the barrel. This year they are scraping the scrapings." Moreover, the spokesman for a group of protestors who had massed outside the Tate, switching their flashlights on and off to mock Creed's installation, noted, "This has gone beyond a joke. The only people who cannot see how ridiculous it is are the organisers themselves."7

Critics upset that a much-lauded new avant-garde artwork isn't real "art" and calling it "ridiculous" and "a joke"—this sounds remarkably like some of the criticisms made of the Fauve paintings exhibited at the 1905 Salon d'Automne. The art has changed a lot—to the point where Braque and his colleagues would probably not recognize it as such. Yet people's reactions to this provocative approach to art don't seem to have changed at all.

43. Frank Stella (American, born 1936), *Quaqua! Attaccati La!*, 1985. Oil, urethane enamel, fluorescent alkyd, acrylic, and printing ink on canvas, etched magnesium, aluminum, and fiberglass, 13 ft. 8 in. x 15 ft. x 1 ft. 9 in. (4.2 x 4.6 x 0.5 m). Hirshhorn Museum and Sculpture Garden, Smithsonian Institution, Washington, D.C. Museum Purchase, 1985

BENDING— AND BREAKING— THE RULES

5

"All profoundly original art looks ugly at first."

Clement Greenberg, n.d.

UNTIL THE LATE 1800S most people who cared were reasonably certain that they knew what art was all about, because there were rules—both written and understood—that laid out the most important parameters. For example, in the Western world, art was traditionally supposed to make its viewers better people, by teaching them valuable moral lessons and by giving them the opportunity to contemplate Ideal Beauty. Such ancient Greek sculptures as the Venus de Milo (plate 44) were then, and for many people still remain, the epitome of such beauty. This art historical icon is only one of myriad three-dimensional images of the ancient goddess of love, beauty, and fertility known to the Greeks as Aphrodite (Venus is her Roman name, by which this particular statue has become known). Even without her arms—which were lost long ago—and despite a

44. *Venus de Milo*, c. 100 B.C. Marble, height 79½ in. (202 cm).
Musée du Louvre, Paris

45. Angelica Kauffmann (Swiss, 1741–1807), *Cornelia Pointing to Her Children as Her Treasures*, c. 1785. Oil on canvas, 40 x 50 in. (101.6 x 127 cm). Virginia Museum of Fine Arts, Richmond. The Adolph D. and Wilkins C. Williams Fund

torso that may seem somewhat soft to a generation accustomed to working out at the gym—the Venus represents female physical perfection. Her serene, generic face is nearly identical to the faces of countless other Venuses.

Venus's descendants populate the world of eighteenth-century Neoclassical painting, illustrated here with *Cornelia Pointing to Her Children as Her Treasures* (plate 45), by the Swiss artist Angelica Kauffmann. This is a fine example of an old-fashioned didactic painting. During the second century B.C., Cornelia was a Roman matron whose sons, Gaius and Tiberius Gracchus, became noted reformers and orators. The scene Kauffmann depicted tells a story that her contemporaries would have recognized immediately. In the course of an informal

46. *Ti Watching a Hippopotamus Hunt*, Old Kingdom, c. 2400 B.C.
Painted limestone relief. Tomb of Ti, Saqqara, Egypt

visit, one of Cornelia's friends displays her new necklace. The friend then urges Cornelia to show off her own wealth, whereupon Cornelia famously declares, pointing to her two young boys, "*These* are my jewels." It may strike us as overly sentimental, but Kauffmann's canvas accomplishes several of the traditional purposes of art. She emphasized the physical beauty of all five figures and further enriched the viewing experience with a wealth of archaeologically correct details in the painted clothing, hairstyles, and architecture. Moreover, and perhaps most important, Kauffmann justified the creation of this large painting by using it to remind people what is important in life.

Traditionally, art was supposed to be not only meaningful but also well crafted and therefore long-lasting. Though it is

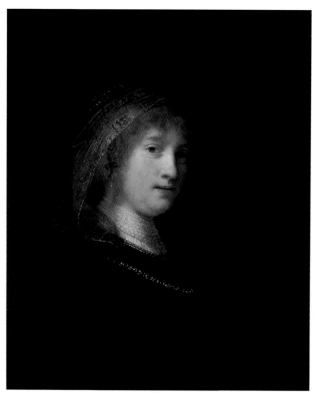

47. Rembrandt van Rijn (Dutch, 1606–1669), *Saskia van Uylenburgh, the Wife of the Artist,* c. 1634–40. Oil on panel, 23¾ x 19¼ in. (60.5 x 49 cm). National Gallery of Art, Washington, D.C. Widener Collection

now more than two centuries old, Kauffmann's picture is still in remarkably good condition. Of course, art history boasts far older works, such as a multitude of ancient Egyptian tomb paintings (plate 46). The colors and carved details of this scene remain fresh-looking and sharp, some 4,600 years after they were first created. According to tradition, art was supposed to be made by the artist's own hand.[1] The works of the noted Dutch Baroque painter Rembrandt van Rijn are highly esteemed in part because of his personal touch. In his most moving works, such as *Saskia van Uylenburgh, the Wife of the Artist* (plate 47), Rembrandt managed not simply to create the believable image of another human being within a convincing space; he also managed to imbue his figures with a palpable sense of humanity.

They look like living, breathing individuals, who always seem to be thinking about something, and responding emotionally to those thoughts, rather than simply posing. It is this special, highly personal aspect of Rembrandt's paintings—even more than his skillful manipulation of light, his golden brown palette, or his sensitive brushwork—that makes his art so distinctive.

All of these factors—ideal beauty, moral lessons, careful attention to craft, and the artist's own hand—have been defining characteristics of visual art for many centuries. Even avant-garde artists of the late nineteenth and early twentieth centuries, such as Monet and Braque, continued to adhere to most of these tenets. For example, even though neither Impressionist nor Fauve art stressed traditional ideas about beauty or symbolic content, paintings in both styles were intended to reflect the touch of the individual artist's hand and to outlast the artists who created them. However, many recent artists have deliberately challenged all the old rules by creating art that is not beautiful in the conventional sense; that has no apparent message; that is intended to be temporary; and that is physically fabricated by other people (though it is usually designed, and supervised, by the artist whose name it bears).

An excellent example of such a work is Robert Smithson's *Spiral Jetty* (plate 48). Created by Smithson in 1970, *Spiral Jetty* was precisely what it sounds like: a jetty (that is, a relatively narrow expanse of rocks and other materials that projects out into a body of water so that people can tie down their boats or go fishing from it). However, instead of the usual straight line, this jetty takes the form of a spiral. As an abstract form, the spiral is attractive and also popular; it crops up in countless cultures and also in nature. However, in the case of *Spiral Jetty*, a tradition-minded viewer might still wonder where the art is.

The aesthetic elements that Smithson had to consider in creating this work were the same ones that Rembrandt faced in painting *Saskia van Uylenburgh* (plate 47). Both artists had to make countless subtle decisions about color, shape, texture, proportion, and overall size. Of course, there are also some important differences between Smithson's works and Rembrandt's.

48. Robert Smithson (American, 1938–1973), *Spiral Jetty*, April 1970. Black rock, salt crystals, earth, red algae, and water, 3 x 15 x 1,500 ft. (0.9 x 4.6 x 457.2 m). Great Salt Lake, Utah. The Dia Center for the Arts, New York

For one thing, *Spiral Jetty* was always meant to be temporary, with the rocks and dirt gradually sinking below the surface of the lake, as they have long since done. The idea of an artwork that was intended to self-destruct would have seemed odd, to say the least, to someone from Rembrandt's era. But "planned obsolescence" is a familiar part of life in industrialized nations today, so this notion hardly seems strange anymore. *Spiral Jetty* is ostensibly a construction with a practical use. However, Smithson's sculpture was clearly never intended to serve as a functional jetty. *Spiral Jetty* doesn't mean anything, in the sense that Kauffmann's painting does, nor does it present viewers with an image that evokes empathy—as Rembrandt's *Saskia van Uylenburgh* does. Yet Smithson's work is not without visual or emotional content, because of the aesthetic beauty of its overall form and the personal associations it conjures up for many observers. Moreover, this work was based in large part on Smithson's political tenets.

Disillusioned with the capitalist gallery system and the "commodification" of art it encouraged, Smithson decided to create works that could exist only outside that system. Indeed, unlike conventional sculpture, *Spiral Jetty* could neither be bought nor sold; it also could not be moved into an art gallery, a museum, or a private collector's home. In addition, as David Hopkins has pointed out, *Spiral Jetty* was constructed "out of wasteland at the edge of the Great Salt Lake . . . where unsuccessful attempts had been made to extract oil from tar deposits."[2] Thus, there is also an ecological theme to this "environmental artwork" or "earthwork" (meaning a work that is constituted of, and located within, the natural environment).[3]

> "When a thing *is seen through the consciousness of temporality, it is changed into something that is nothing . . . it ceases being a mere object and becomes art."*
>
> Robert Smithson, n.d.

Spiral Jetty was not made by Smithson's own hand. Obviously, nothing that large (1,500 feet long and 15 feet in diameter) could be physically constructed by any one person. In fact, professional operators were required to work the heavy equipment needed to move the six thousand tons of rocks and earth. Yet the piece is still Smithson's, since it was his idea and since he designed and supervised the erection of the entire piece. However, it might be seen by some as more a construction project than a sculpture, in the usual sense of the term—something that a civil engineer, rather than an artist, might have put together. Because it was temporary, and because its spiral form could best be appreciated when seen from above, only people who could get to Utah at the right time and who had access to an aircraft could see *Spiral Jetty* in person. As a result, like most earthworks—especially works, like this one, that are "site-specific," or designed for a particular place from which they cannot be moved—*Spiral Jetty* can now be studied only indirectly, through what is known as "documentation": photographs, drawings, written accounts, and a half-hour film made by the artist in 1970. Yet *Spiral Jetty* was, in fact, a sculpture. Despite

the deliberate challenges it made to the standard definition of "sculpture," it remained a nonfunctional, thought-provoking work in which aesthetic issues were always paramount.

Many of Smithson's pieces questioned the traditional distinction between an engineering project and a work of fine art. In recent decades, numerous other artists have created works that clearly fall within the general category of "art," but can't be simply described as "painting," "sculpture," or "architecture." Traditionally speaking, a painting (plate 49) is a two-dimensional arrangement of colored shapes applied to one side of a canvas, panel, or other support. A painting knows its place and simply hangs quietly on the wall. A sculpture, on the other hand (plate 50), is a three-dimensional artwork, generally carved from a dense material like stone or wood or cast from a metal alloy such as bronze. A traditional sculpture stands by itself, within our space yet separated from us—often on a pedestal. You can walk around a traditional, freestanding sculpture—in fact, you really have to do so, to appreciate its many views. In most cases, a traditional sculpture is also monochrome, often the color of the material from which it has been made.

Traditionally, a work of architecture (plate 51) is a large, three-dimensional structure that encloses a space in which people live, work, pray, or play. Often architecture is enlivened by the addition of paintings or sculptures, but it seems nearly inconceivable that a work of architecture could ever be confused with either of those forms. And yet, especially during the last several decades, artists have been creating art that fits comfortably within more than one, or none, of these categories.

Frank Stella is one of the clearest examples of an artist who began working securely within one category but who, for at least a quarter-century, has been experimenting with art that no longer fits a single designation. In 1959 Stella began his career as a painter, producing large, rectangular, mainly monochrome canvases that could be labeled Minimalist, as could his related "pinstripe" series (paintings covered with dark gray pigment, interrupted by narrow parallel strips of unpainted canvas). Although avant-garde, these were definitely paintings.

49. Leonardo da Vinci (Italian, 1452–1519), *The Mona Lisa*, also known as *La Gioconda*, 1503–6. Oil on wood, 30⅜ x 20⅞ in. (77 x 53 cm). Musée du Louvre, Paris

50. Michelangelo (Italian, 1475–1564), *David*, 1501–4. Marble, height 14 ft. 3 in. (4.3 m). Galleria dell'Accademia, Florence

51. John Haviland (British, 1792–1852), Dorrance Hamilton Hall (originally the Pennsylvania Institute for the Deaf and Dumb), 1824–25. The University of the Arts, Philadelphia

However, by the mid-1970s Stella's pictures were becoming more and more sculptural. They were still fastened securely to the wall, but they stopped being rectangular—or any other shape that has a name. Increasingly, a large portion of each work was pierced, so that the wall was visible behind it. The shapes bulged into arcs and began curving out into the viewer's space, often casting shadows that became an integral part of the overall design. At the same time, Stella's artworks were growing into huge, wall-filling constructions, and they were made from a proliferating range of materials, including glitter, crushed glass, and wire netting, along with bright, sometimes garishly colored paint, all of it supported by cutout shapes made of etched aluminum (plate 43).

These no longer seem like paintings, yet they don't really seem to be sculptures, either. There is a venerable category called relief sculpture, meaning three-dimensional art that is designed to hang on a wall rather than stand on a pedestal. But the term *relief sculpture* seldom refers to anything as large as Stella's newer works. In most university slide libraries, Stella's work is still listed under "Painting," but that hardly resolves the issue. To further complicate the matter, the National Gallery of Art in Washington, D.C., recently unveiled a large outdoor metal work by Stella that is definitely a sculpture.[4] Ultimately, of course, it is the art that matters, not its label. Yet labels are a necessary tool for thinking, talking, and writing about art. The very fact that the old categories no longer work tells us something important about recent developments in art.

Other artists besides Stella—notably Elizabeth Murray—have explored the increasingly permeable boundary between painting and sculpture. However, no one seems to have enjoyed playing around with the myriad ambiguities that result from such an exploration as much as Roy Lichtenstein. One of the pioneers of Pop art,[5] in the early 1960s Lichtenstein became famous for his oversize, oil-and-acrylic-on-canvas images based on comic strips. Later, he also worked in other media, including printmaking and sculpture. He made three-dimensional works out of clay, stone, and metal, but his most interesting sculptures

52. Roy Lichtenstein
(American, 1923–1997),
Brushstroke, 1981.
Painted and patinated
bronze (edition of six
plus maquette),
31⅜ x 13¾ x 6½ in.
(79.5 x 35.1 x 16.5 cm).
Courtesy of the Estate
of Roy Lichtenstein

are a large series of colorful cast-bronze works made during the 1980s and 1990s, which intentionally cross and recross the traditional dividing line between painting and sculpture. Lichtenstein is one of several painters-turned-sculptors who never fully made the transition to three dimensions. Most of his sculptures were clearly conceived in two dimensions and are nearly as flat as his canvases. The effect of seeing these sculptures in person is quite startling. Soon you realize that what would be white spaces in one of Lichtenstein's paintings—say, a woman's cheek, or the rays of light streaming down from a table lamp—are actually thin air in his sculptures. The white areas you think you see in the latter are simply the blank wall behind it, visible between two outlines made of metal.

An example from one of Lichtenstein's most amusing, and intriguing, sculptural series—related, as are most of his three-dimensional works, to an earlier series of paintings—is his *Brushstroke*. Here (plate 52), in a typically playful way, he created three separate metal brush strokes—one each in red, yellow, and blue paint—standing on a base, with a vertical orientation that suggests a human figure. There are at least two art historical jokes here. Before he developed his characteristically sharp, clear Pop method of painting, Lichtenstein was an Abstract Expressionist. Clearly, these sculpted marks are much more closely related to the large, thick, aggressive brush strokes of the New York School (yet another name for Pollock et al.) than they are to Lichtenstein's comic-strip paintings. Also, whereas strokes of paint usually depend for their very existence on a canvas or some other kind of support, here the brush strokes stand alone. Moreover, there is the issue of multiple views. In sixteenth-century Italy a significant body of art theory was devoted to the Mannerist (essentially, anti-Renaissance) idea that sculpture should favor a form called *la figura serpentinata* (a serpentine, twisting, flamelike composition). This required viewers to walk all around each work, since no sculpture could ever be completely understood from any one angle. However, a work like Lichtenstein's *Brushstroke* provides no view at all from either side (indeed, a photograph taken from the side of one of

these metal works would show only a thin, dark line), and there is obviously no reason to look at the work's back, since it would be identical to the front, only reversed.

As noted above, architecture is one traditional category that would seem to be immune from the sort of "label confusion" sometimes engendered by contemporary art. However, since the 1970s several artists, including Siah Armajani and Donna Dennis, have been creating works that confound even this category. Our illustration of Dennis's *Tourist Cabin Porch (Maine)* (plate 53) is an excellent example both of the fluidity between sculpture and architecture and of the potentially misleading nature of photographs that reproduce works of art.

Tourist Cabin Porch certainly looks like what the title says it is. All the usual elements are there, made from the materials you would expect: metal screening, glass windows, wood and paint, and the kind of ugly floral curtains found in so many vacation rentals. The interior electric light even works, so clearly this must be "architecture." However, Dennis's work lacks a couple of elements that are generally considered essential for architecture. For one thing, this "porch" isn't actually attached to anything—except the wall with the window and the door in it. You would expect the porch to lead directly into the cabin proper, but there *is* no cabin, only a porch. That is strange, but perhaps not strange enough to remove this work from the realm of architecture. However, its scale makes the break complete. *Tourist Cabin Porch* is just six and a half feet high at the roof's peak and only slightly wider—which means that an average-size adult couldn't really use this space.

So, is nothing sacred? Apparently not, and—just to slaughter one more sacred cow, in terms of the way one expects visual art to behave—there is the example of kinetic sculpture: art that literally moves. There is a long tradition of painting and sculpture that implies motion, such as the dynamic compositions from Hellenistic Greece and in various European countries during the Baroque era. However, very little art made before the twentieth century was actually intended to move. Some of the most celebrated kinetic sculptures from the 1930s through

53. Donna Dennis (American, born 1942), *Tourist Cabin Porch (Maine)*, 1976.
Wood, Masonite, paint, glass, pencil, metal, fabric, plastic, electrical fixtures,
porcelain door knob, and cement blocks, 78½ x 82 x 26½ in. (199.4 x 208.3 x
67.3 cm). Courtesy of the artist

54. Alexander Calder (American, 1898–1976), *Snow Flurry, I,* 1948. Hanging mobile: sheet steel and steel wire, painted, height 94 x diameter 82¼ in. (238.8 x 208.8 cm). The Museum of Modern Art, New York. Gift of the artist

the 1970s are the famous "mobiles" made by Alexander Calder. He also created a series of beguiling sculptures powered by hand cranks, or electric motors, as well as some highly effective sculptures that do *not* move. More recently, several sculptors—including George Rickey, Niki de Saint Phalle, and Jean Tinguely—have continued to experiment with various types of three-dimensional movement in their works.

Calder remains the preeminent master of kinetic sculpture. An apparently simple work like *Snow Flurry, I* (plate 54) demonstrates why. Fashioned from just a few humble materials (wire plus white-painted bits of sheet metal), *Snow Flurry, I* manages to be both abstract and whimsical at the same time. Without the clue provided by its title, this mobile would still present an enormous number of constantly changing profiles, each one physically balanced and aesthetically satisfying. In addition, this sculpture projects an air of lightness, in terms of both materials and spirit. Once the title becomes known, *Snow Flurry, I* suddenly acquires an additional layer of humor, as the white disks become snowflakes blown by gusts of wind.

> *"When I have used spheres and discs, I have intended that they should represent more than what they just are. More or less the earth is a sphere, but also has some miles of gas about it, volcanoes upon it, and the moon making circles around it, and as the sun is a sphere—but also is a source of intense heat, the effect of which is felt at great distances. A ball of wood or a disc of metal is rather a dull object without this sense of something emanating from it."*
>
> Alexander Calder, 1951

The many different kinds of challenges made to traditional categories of art discussed above have led, in many cases, to even more unusual—and controversial—artworks. These are the focus of chapter 6.

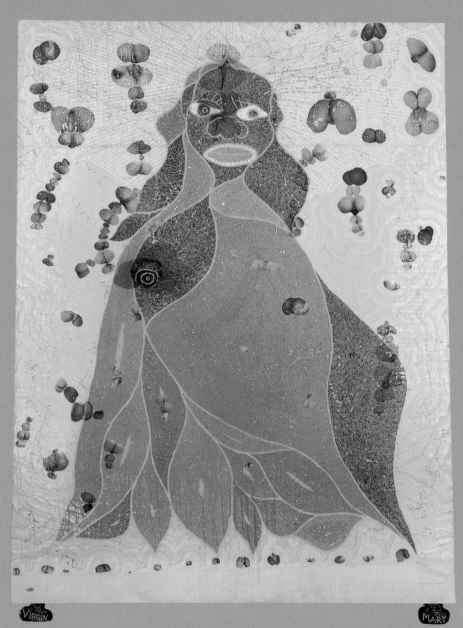

55. Chris Ofili (British, born 1968), *Holy Virgin Mary*, 1995. Acrylic paint, oil paint, polyester resin, paper collage, glitter, map pins, and elephant dung on canvas, with two elephant dung supports, 96 x 72 in. (243.8 x 182.9 cm). Courtesy of the artist and Victoria Miro Gallery, London

NEW MATERIALS, NEW RULES

6

> *"That's what fascinates me—
> to make something I can never
> be sure of, and no one else can
> either. I will never know, and
> no one else will ever know. . . .
> That's the way art is."*
>
> Willem de Kooning, 1972

THE PREVIOUS CHAPTER summarized several ways in which avant-garde artists have challenged the traditional definitions of visual art over the past one hundred years. However, most of the examples discussed there utilize the same kinds of media and techniques with which artists in the Western world have been working for many centuries. Another controversial development, one that has attracted considerable attention during the past few decades, involves making art from unconventional, sometimes shocking materials. At the same time, and partly because of these new materials, much recent art has been displayed in unexpected ways.

In the past, "fine art" (meaning paintings and sculpture of the sort that have traditionally been displayed in art museums) was restricted to certain types of materials. Paintings were made

of oil, watercolor, tempera, or—later—acrylic paint on panel, paper, or canvas, while sculpture was cast in bronze or carved from wood or stone. Many artists still use these venerable materials, but recently art has also been made from an astonishing range of nontraditional substances, from fragments of newsprint to broken crockery, a pile of candy, or a decaying cow's head. The strangeness of these materials has sometimes threatened to overshadow the actual artworks of which they are a part. Yet no matter how outrageous the materials that constitute a particular painting or sculpture, that work can still be analyzed in the same ways as a work made by Leonardo or Michelangelo.

In the fall of 1999 the mayor of New York City, Rudolph Giuliani, precipitated a major cultural, financial, and political crisis by threatening to withdraw the entire $7.2 million annual budget from the Brooklyn Museum of Art and also to evict this venerable institution from its city-owned building. The mayor did this ostensibly because of his disgust with one work in *Sensation*, a touring exhibition of some ninety works by forty young British artists. Inevitably, lawsuits and countersuits were filed. Ultimately the courts found in favor of the museum, forbidding Mayor Giuliani to engage in any sanctions and dismissing all later related complaints. The publicity spurred an enormous public outcry, both for and against the mayor's position, and people lined up to see the show; as a result the artists in it became far more famous here than they had been before.

Attempts at art censorship are hardly new. What was extraordinary about the *Sensation* case was the fact that the catalyst for the entire brouhaha—the work that the mayor condemned as "sick, offensive, and anti-Catholic," without ever actually seeing it—was a surprisingly old-fashioned Christian devotional image: *Holy Virgin Mary* (plate 55), a 1995 painting by the Manchester-born black artist Chris Ofili. The materials he used to cover this large, highly decorative canvas include oil paint, fragments of photographs showing naked human buttocks, glitter, and—famously—elephant dung. It was that last item that sent Giuliani, and others, round the bend. However, the notorious dung

is actually three small balls of brownish material that looks like dried mud, encased in clear resin and ornamented with colorful map pins. Had the label not specified what it was made of, it would have been virtually impossible to guess. Moreover, it turns out that Ofili, a practicing Roman Catholic whose family comes from Nigeria, has long included elephant dung in his works, partly as a reference to a traditional African practice in which the dung is used to honor, not insult, a given subject. In the Western world, however, it is highly unusual to use any sort of excrement as an artist's material.[1] Ofili certainly knew that his choice would generate a certain amount of surprise, though nowhere else was the response to his painting as extreme as it was in New York.[2]

The oddest thing about the ruckus over *Sensation* is the fact that the naysayers largely ignored a number of other works with elements that seem just as objectionable as the elephant dung—namely, a life-size self-portrait bust by Marc Quinn, made entirely from the artist's own frozen blood, and Damien Hirst's well-known series of formaldehyde-preserved farm animals and sharks, and his *A Thousand Years* (Collection of Charles Saatchi, London), a large, steel-and-glass box inside which live maggots feasted on a rotting cow's head, while flies—fed on sugar water—met a violent end through their encounters with the aptly named "insect-o-cutor." According to the catalogue for *Sensation*, Hirst's work is "an examination of the processes of life and death: the ironies, falsehoods and desires that we mobilise to negotiate our own alienation and mortality."[3] That description certainly applies to *A Thousand Years*. Nevertheless, this piece is (intentionally) difficult to look at even in reproduction, and genuinely disturbing in person. Whatever one may think about Hirst's apparent grandstanding, about this work's identity as "art," about the aesthetic value of the composition, or about the ethics or wisdom of displaying such materials inside a large public space, this definitely captures the viewer's imagination. There are obvious art historical precursors to Hirst's piece—including paintings, drawings, and prints made by such esteemed artists as Théodore Géricault and Francisco Goya, both of whom produced

numerous images of severed limbs. But the European masters did so in the process of making powerful political statements about the horrors of war, the dangers of government corruption, and the like, which gives them additional gravitas. Moreover, those were representations of severed limbs, not the actual body parts. Making a political statement seems not to have been Hirst's purpose in creating *A Thousand Years*. Still, this piece does have serious content, forcing viewers to contemplate death, decay, and other unpleasant subjects.

As absurd as it may sound, aesthetics—in particular, the manner of presentation—is as important to Hirst's sculptures as it is to those made by, say, Rodin or any other more traditional sculptor. The sharks and other sea creatures suspended inside Hirst's formaldehyde-filled tanks would be startling under any circumstances. But the fact that each one floats eerily in the exact center of its perfectly proportioned rectangular box makes the effect that much more shocking. Likewise, the shock value of the cow's head in *A Thousand Years* increases because it is displayed in isolation, rather than atop a pile of other decaying body parts (or still attached to the rest of the cow). As a result, viewers can't help thinking about its fragmentary nature and the violence required to sever the head from the animal's body. Further increasing the queasiness quotient, the insect-o-cutor is a particularly industrial and dangerous-looking machine, more like something from a modern prison's death chamber than one of those "bug zappers" so popular at backyard barbecues. Hirst has also provided great expanses of empty space within his two-part container, thus encouraging viewers to focus on the movement of the individual flies. In addition, the contrast with the cold, pristine black, white, and silver colors and the crisp, clean lines of everything else in this work makes the deep red hues and ragged edges of the cow's head seem even more striking.[4]

The art of Julian Schnabel is not nearly so radical, or so unnerving, as Hirst's sculptures. Yet during the 1980s Schnabel (perhaps more familiar now as a filmmaker) was one of the hottest and most controversial young painters around. His works

56. Julian Schnabel (American, born 1951), *The Walk Home*, 1984–85. Oil, plates, copper, bronze, and fiberglass on Bondo on six wood panels, 112 x 232 x 6 in. (284.5 x 589.3 x 15.2 cm). The Broad Art Foundation, Santa Monica, California

sold for enormous sums, and eager collectors vied to put their names on waiting lists to purchase as-yet-uncreated Schnabel originals. Schnabel was part of the wave of Neo-Expressionism that swept through the United States and Europe (especially Germany and Italy) during the 1980s. Inspired by the European Expressionist movement—which had appeared at the same time as Fauve art, with which it shared many stylistic traits (see plate 88)—Neo-Expressionism sometimes makes pointed political references and conveys a rather dark mood even when totally abstract.[5] The large, brushy canvases typically feature earth tones (brown, beige, gray, black) and uneven, "expressive" textures created by areas of extremely thick pigment, as well as the occasional addition of mixed media (anything other than canvas and paint). In Schnabel's case, the mixed media with which he worked included deer antlers, driftwood, lengths of velvet, and—most famously—broken ceramic dinner plates (plate 56).

Even when they are not immediately recognizable as plates, these pieces of glazed clay add a remarkable richness to Schnabel's painted surfaces. For some viewers, they also evoke strong emotional—and philosophical—associations. However,

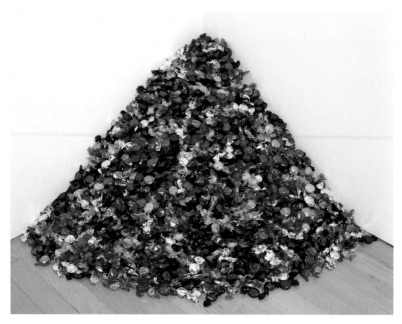

57. Félix González-Torres (Cuban/American, 1957–1996), *Untitled (Portrait of Ross in L.A.)*, 1991. Multicolored candies individually wrapped in cellophane, endless supply, ideal weight 175 lbs, dimensions variable. Courtesy of Andrea Rosen Gallery, New York

the notion that a young, New York–based artist was achieving fame and fortune by essentially recycling shattered crockery struck other observers as absurd. A good indication of the heights to which this artist's reputation had ascended by the mid-1980s is G. B. Trudeau's series of *Doonesbury* comic strips featuring a thinly disguised Schnabel (represented by the ever trendy artist, J. J.) in a scathing parody of that obscure form of jargon known as "artspeak."

One of the more memorable sequences in the 1993 *60 Minutes* program mentioned in chapter 3 occurred when one collector showed Morley Safer a piece by the Cuban-born artist Félix González-Torres. Like Schnabel's plates, González-Torres's sculptures made of wrapped candies are an easy target for critical barbs, and Safer took full advantage of the opportunity to disparage the piece, which was similar to the one illustrated here (plate 57).

On one level, *Untitled (Portrait of Ross in L.A.)* is exactly what it looks like: a pile of commercially manufactured hard candies (in this case, Fruit Flashers), displayed in the corner of a room in a gallery, museum, or private home. The choice of candy as a sculptural material is odd enough; far stranger is the artist's wish for this work to be interactive: visitors are encouraged to take one, or several, pieces of the candy, which startlingly contradicts standard museum policy ("Don't touch!"). Since *Untitled* was not meant to be temporary, to prevent the work from ultimately disappearing González-Torres provided its owner with a large supply of additional candy, which can be added periodically to replenish the piece. To someone accustomed to the idea that the dimensions and shape of an artwork never change, González-Torres's approach may seem peculiar. However, it represents an important, and consistent, aspect of his oeuvre (the total body of work produced during his lifetime). He was always fascinated both with the concept of "multiples" (myriad identical art objects) and with ways that gallerygoers could participate in an artwork.

Like all visual art, *Untitled* can be analyzed in purely formal terms. It consists of a number of different colors—contributed by the shiny candy wrappers—which provide a powerful contrast to the white walls and neutral-hued floors of most public art spaces and to the glass walls of the private home in which this work is usually displayed. The size and shape of the candy pile vary, depending on where it is located and on how many candies have been removed, but it always forms a kind of irregular pyramid. The work's surface is obviously irregular, because of the slightly different angle at which each candy is placed. The surface becomes even more lively when the light catches individual bits of cellophane and colored paper. Sound is also a significant element in this work: when someone takes a candy, its paper wrapper rustles, and the pile shifts.

González-Torres's *Untitled*, like the other works in this series, challenges traditional ideas about materials, techniques, the degree of an artist's control, the touch of the artist's own hands, and the issue of interactivity. Some viewers have

> *"That is what the title of artist means: one who perceives more than his fellows, and who records more than he has seen."*
>
> Edward Gordon Craig,
> *On the Art of the Theatre*, 1911

a tendency to see works like this as frivolous, because of the associations that go along with candy: childhood, pleasure, play. However, González-Torres has actually made a highly sophisticated work by juxtaposing brightly colored sweets with the subject of death. The parenthetical subtitle, *Portrait of Ross in L.A.*, seems at first to be a throwaway line: obviously no one looks like a pile of wrapped candy. However, Ross was González-Torres's life partner, who had recently died of complications from AIDS, the disease to which the artist himself also succumbed in 1996. This sculpture is not a likeness of Ross, but it is a memorial, some aspects of which are surprisingly specific, though admittedly unconventional. (For example, the comment in the caption, "ideal weight 175 pounds," is not arbitrary; it refers to Ross's weight.) Without researching González-Torres's life story, there is no way to know about the symbolic significance of the work. However, *Untitled*, like all works of visual art, must also stand on its own—in this case, as a piece that offers viewers a wealth of theoretical and sensual cues, whether or not its autobiographical content is known.

In addition to elephant dung, cow's heads, broken plates, and hard candies, in recent years artists have worked with a staggering array of other materials. For example, America's "bad boy" of sculpture, Jeff Koons, has made several forty-foot-tall puppies entirely out of living flowers (they are supported by an invisible metal grid and kept alive via an ingenious set of hidden water sprinklers); and the same Janine Antoni who painted using her hair as a brush (plate 41) also gnawed into shape several self-portrait busts made of chocolate. A kindred spirit, Vik Muniz, is known for his portraits of celebrated figures from various fields (Jackson Pollock, Sigmund Freud, Charles Baudelaire) made out of chocolate syrup. However, the growing affinity of professional visual artists for working with foodstuffs extends well beyond candy. Recent examples have included

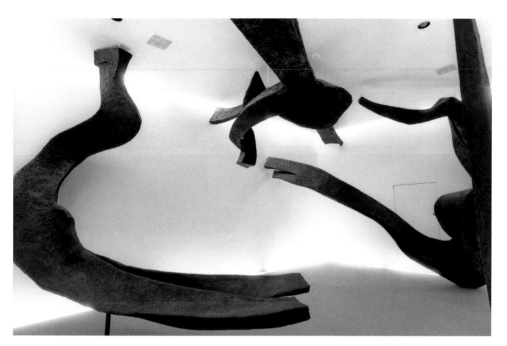

58. Herbert Ferber (American, 1906–1991), *Sculpture To Create an Environment*, 1961. Polyvinyl coated fiberglass, 12 ft. x 24 ft. 5 in. x 17 ft. 1 in. (3.7 x 7.4 x 5.2 m). Jane Voorhees Zimmerli Art Museum, Rutgers, The State University of New Jersey, New Brunswick, New Jersey. Gift of Herbert Ferber

works featuring ketchup (Paul McCarthy), peanut butter and jelly (Rafael Sánchez), and miniature custard-filled cream puffs (Adriana Kulczycky).

Another element with which avant-garde artists have experimented in recent decades is the scale of what they create. Today, one sculpture can fill an entire room. For example, rather than being confined to a narrow column of space, the painted fiberglass forms created by Herbert Ferber are just as likely to project downward from the ceiling or horizontally out from the walls. In the wonderfully surreal gallery space that he designed for Rutgers University (plate 58), Ferber's heavy, dark-toned, irregular shapes appear weightless, as though they were floating or flying in all directions. The indirect lighting, the mysterious cast shadows, and especially the material on the gray-carpeted ceiling and walls (which gives them the same color and texture as the floor) all accentuate the viewer's sense of being underwater.

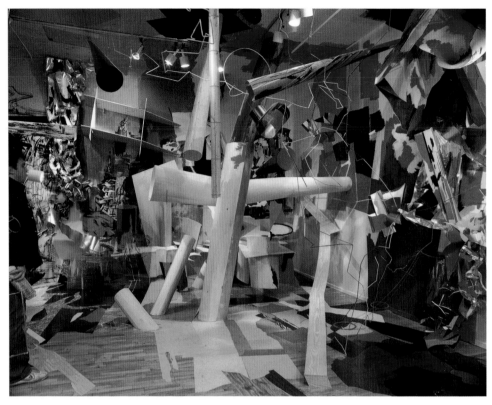

59. Judy Pfaff (British/American, born 1946), *3-D*, 1983. Wood, steel, plastic, paint, and contact paper, 22 x 35 ft. room (6.7 x 10.7 m). Holly Solomon Gallery, New York

Judy Pfaff takes a very different approach to "installation art" (plate 59).[6] She is especially noted for the temporary sculptures she constructed within gallery and museum spaces during the early 1970s and 1980s. Typically, these were made of innumerable bits and pieces of wood, metal, plastic, and paint—some that she had scavenged and others that were new, combined to form a dense interior environment so crowded that it was occasionally difficult to pick one's way through. Whereas Ferber's environment uses subtle variations on one type of monochromatic form, Pfaff's are a riot of colors, textures, shapes, and sizes. If Ferber's shapes appear monumental and slow moving, hers seem to carom wildly off the gallery walls and all around the room. Pfaff's installations are busy, crammed full of visual

excitement; Ferber's are more restrained, yet no less reward-ing. Both artists create new environments with which visitors must interact.

In a standard exhibition space, you might encounter a con-ventional sculpture, a single object on a pedestal, that occupies its own discrete space, whereas with an installation, the whole room is the sculpture. Think of it as the difference between going to see a friend's expensive new refrigerator (which would obviously affect the decor, and hence the overall mood, of her kitchen), as opposed to visiting a friend who had recently had her entire kitchen remodeled. Ferber's and Pfaff's pieces liter-ally surround you with colors and shapes, which often spark a more immediate, more visceral response than you might have to a traditional gallery or museum display.

Although the pile of candies that makes up González-Torres's *Untitled* has no definite form, at least each individual candy is solid, as one would expect sculpture to be. However, as its name implies, there is nothing solid about Claes Olden-burg's *Soft Toilet* (plate 60). If it seems peculiar for a sculpture to be made—as this one is—from materials such as vinyl and kapok (the down from the seeds of a silk-cotton tree, used to stuff the vinyl), it is equally strange to see a common household plumbing fixture that is "soft." After all, of what possible use can a toilet be if it doesn't stand up? Neither the tank nor the bowl would be able to hold water; the handle wouldn't flush; and of course it couldn't begin to support a person's weight.

Such practical matters aside, the toilet is hardly a conven-tional sculptural subject. However, as a Pop artist in the early 1960s, Oldenburg was interested in representing—and simul-taneously subverting—all sorts of objects from the everyday world. Just as Lichtenstein painted canvases that looked like comic strips, so Oldenburg created sculptures representing typically American foods (notably pizza, burgers, and fries) and the detritus of modern life, such as ashtrays filled with cig-arette butts. One of his more noteworthy projects is the series of bathroom-related soft sculptures that includes not only a toi-let but also a tub, sink, and medicine cabinet. Oldenburg didn't

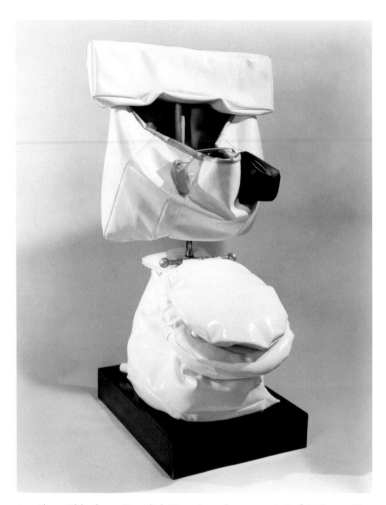

60. Claes Oldenburg (Swedish/American, born 1929), *Soft Toilet*, 1966. Vinyl, Plexiglas, and kapok on painted wood base, 57⅛ x 27⅝ x 28⅛ in. (144.9 x 70.2 x 71.3 cm). Whitney Museum of American Art, New York. 50th Anniversary Gift of Mr. and Mrs. Victor W. Ganz

attempt to replicate these objects, never seeking to fool the viewer into thinking they might be real (that idea became popular with a later generation of sculptors—see chap. 7). Rather, he altered the most fundamental qualities of these objects: their functionality, their solidity, and their scale. Oldenberg generally remained faithful to the original colors of the objects from which he worked, but in many cases—though not with his plumbing series—he significantly increased their sizes, producing gargantuan soft ice

bags, light switches, and ice-cream cones. Later Oldenberg went on to design enormous "hard" sculptures, including a motorized Swiss army knife and a startling series of huge

"If I didn't think what I was doing had something to do with enlarging the boundaries of art, I wouldn't go on doing it."
Claes Oldenburg, n.d.

public monuments. The latter include, for example, the forty-foot-tall metal *Clothespin* (1976) in downtown Philadelphia and a set of four giant badminton *Shuttlecocks* (1994), each one over nineteen feet tall, that are scattered around the Sculpture Park at the Nelson-Atkins Museum of Art in Kansas City, Missouri. Even though it is representational, his art is still avant-garde, because of its unusual subject matter and its unexpected materials.

Another shocking aspect of some avant-garde art is the way, and the place, it is displayed. In mid-March of the year 2000 Annikki Luukela, an artist from Finland, created a temporary work celebrating the visit of Helsinki's mayor to Washington, D.C.[7] She decided to transform the entrance to the cold gray steel-and-concrete subway station at the southern end of Dupont Circle. Luukela did this by installing forty-five moving lamps that projected various colored lights and a computer programmed to play recordings of Finnish songbirds. On paper, this sounds strange, and in fact some regular Metro commuters did find their first exposure to the piece rather puzzling. However, on a visit to Washington while the work was still up, I spent half an hour riding up and down these escalators—and found the experience delightful. Luukela said she had intended to mimic the aurora borealis, a common sight in her homeland. As someone relatively unfamiliar with the actual northern lights, I can only say that this virtual version included some gorgeous effects, as the colors and lights splashed, irregularly, over the semicircular ceiling of the subway tunnel. The artist definitely caused Metro riders to see, and feel, that space in a new way. In fact, I still think longingly of the Finnish artist's piece as I travel through other, far less interesting subway stations.

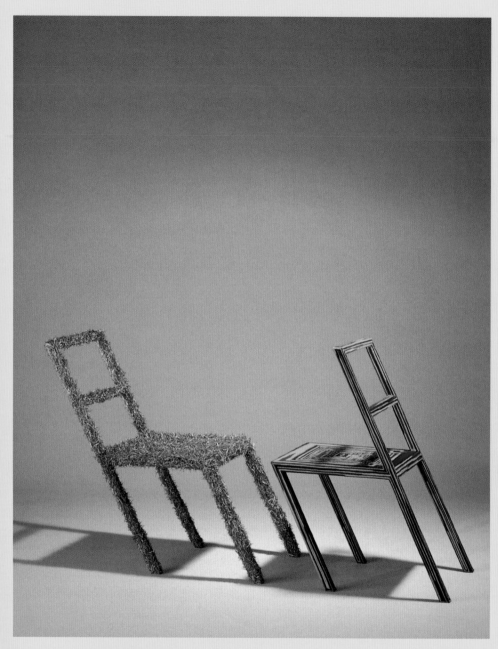

61. Lucas Samaras (Greek/American, born 1936),
Untitled, 1965. Pin chair: wood, pins, and glue,
35⅜ x 19¼ x 35¾ in. (89.7 x 48.8 x 90.9 cm); yarn
chair: wood, yarn, and glue, 35⅜ x 18 x 26⅝ in.
(89.7 x 45.7 x 67.6 cm). Walker Art Center,
Minneapolis. Art Center Acquisition Fund, 1966

ART INVADES LIFE, AND VICE VERSA

7

You be the judge: a pile of empty beer bottles, dirty ashtrays, coffee cups and candy wrappers. It's crud, but is it art?

Cleaner Emmanuel Asare didn't think so when he arrived at London's Eyestorm Gallery Wednesday morning, so he threw the lot into the trash. It turns out the "installation" had been created by British artist Damien Hirst after the launch party for his Painting by Numbers *show the night before.*

"I didn't think for a second that it was a work of art. It didn't look much like art to me," Asare told the Sun *newspaper.*

The 35-year-old Hirst said the mistake was "fantastic, very funny." When gallery workers discovered the work had been trashed, they hastily recovered the piece and reconstructed it from photographs.

"One Man's Art . . . ," Washington Post, *20 October 2001*

THERE NEVER USED TO BE any question about the difference between art and life. No matter how closely it resembled its subject matter from the real world, art was clearly separate from that subject—until twentieth-century artists began to challenge even this most basic distinction.

This phenomenon began with the works of Pablo Picasso—specifically, his Cubist collages from 1912–13 (plate 62). Numerous scholars have written eloquently about the history and significance of Cubism.[1] Suffice it to say here that Cubism—invented by Picasso and Georges Braque around 1908—really was as important a development in the history of Western art as everyone says it was. Following close on the heels of Fauvism, Cubism took to the next level the modernist revelation that visual art no longer had to faithfully reproduce the colors and shapes that existed in the real world. Cubist paintings retain some tie to observed reality, since they are usually based on an identifiable subject, such as a figure holding a musical instrument or a still life. Yet it is often difficult to identify the subject matter in these works because the Cubists distorted forms to the point where they became unrecognizable.

One helpful way to think about Cubism is to imagine an artist painting a vase of flowers that has been placed on a nearby table. A traditional painter would sit or stand in one place, focusing his entire attention on a single view. However (at least, in theory), a Cubist painter would walk all around the vase, making a mental note of how it appeared from every possible angle. Then the Cubist painter would paint all these views, simultaneously. On an intellectual level, this introduces the concept of the fourth dimension (time) into a given painting. In purely visual terms, it creates a dense, complex composition, made up of myriad small, sharp fragments, as though the vase had been viewed through a kaleidoscope. That is why Cubist subjects are so difficult to decipher.

If they seem obscure to twenty-first-century viewers, imagine how hard it was for contemporary gallerygoers to discern any relationship between the titles and the subjects of Cubist

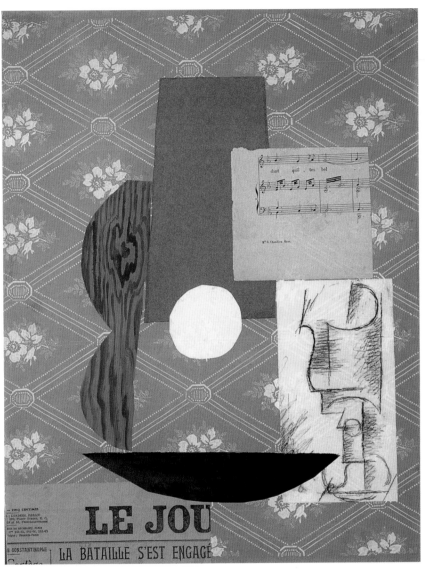

62. Pablo Picasso (Spanish, 1881–1973), *Guitar and Wine Glass*, 1912. Collage and charcoal on board, 18⅞ x 14⅜ in. (48 x 36.5 cm). McNay Art Museum, San Antonio, Texas. Bequest of Marion Koogler McNay

> *"The fact that for a long time Cubism has not been understood and that even today there are people who cannot see anything in it, means nothing. I do not read English, an English book is a blank book to me. This does not mean that the English language does not exist."*
>
> Pablo Picasso, 1923

paintings. Indeed, many critics initially despised Cubism because of its extreme stylization. For example, one writer asserted, "The real meaning of this Cubist movement is nothing else than the total destruction of the art of painting—that art of which the dictionary definition is 'the art of representing, by means of figures and colors applied on a surface, objects presented to the eye or to the imagination.'"[2] Undeterred, the Cubists pursued a radically new way of painting, seeing, and thinking, and by 1911 they were questioning yet another traditional idea about visual art: the distinction between art and life. Collages (from the French verb *coller*, meaning "to glue") had certainly existed earlier, but only as a technique for making preparatory sketches for other, larger works in oil paint on canvas. In 1912–13 Picasso and Braque pioneered yet another type of art, when they began using this technique in their finished pictures. They were, in fact, roundly criticized for using collage, since at that time this technique was considered a kind of cheating. After all, in 1912, the point of making art was still to use one's hard-earned technical skills to create a believable facsimile of something from the real world—as it had been, in the Western world, for many centuries. Therefore a picture, part of which contained an actual fragment of something from the real world (in this case, bits of a French newspaper), was not "art." If Picasso had created a representation of a piece of newsprint using his paints, charcoal, or other traditional materials, presumably that aspect of his picture would have been acceptable—although the puzzling abstraction of his compositions might still have been problematic for most viewers.

Quite a few other avant-garde artists have dealt with this same question—of art and life—in very different but equally innovative ways. For example, they have sometimes created art

that looks suspiciously like something else—furniture, say, or even plumbing. The humble chair has long exerted an attraction, not just for industrial designers but also for modern sculptors and painters. At the end of the nineteenth century, Vincent van Gogh created an enormously evocative "portrait" of his friend and fellow artist Paul Gauguin by painting an image of the latter's favorite chair. A century later a number of artists—including Lucas Samaras and Scott Burton—produced thought-provoking variations on the chair theme in three dimensions. Even the most beautifully designed and expensive chairs are different from sculptures. The former have traditionally been considered examples of design, which means they serve some practical function, whereas the latter is fine art, which is not supposed to do anything.[3] On the most basic level, people sit on chairs; whereas everyone (González-Torres aside)—from parents, to teachers, to museum security guards—strongly, and properly, discourages visitors from touching works of art.

With any of the works in Lucas Samaras's extravagantly funny—and sometimes sinister—*Transformations* series, there is no question of trying to sit down. In the two examples illustrated here (plate 61), both "chairs" are tilted at awkward angles, threatening to collapse at the slightest touch. One "chair" seems otherwise relatively benign, with only its unusual seat—made of multicolored yarn—setting it apart from myriad others. However, the second "chair" is clearly dangerous, bristling with pins that cover its entire surface; this chair is frightening rather than welcoming.

In contrast to Samaras's works, Scott Burton's chairs made from rock are far more ambiguous. Their titles imply that these "chairs" are pieces of furniture. But whereas Samaras's works are constructed out of yarn, pins, and other materials that are not normally part of the fine-art world, Burton's are made of solid stone—a material that might be used by a traditional sculptor. The questions surrounding the proper classification of Burton's pieces have continued long after his death in 1989. They have several of the standard characteristics of a chair: solidly built, they would certainly support anyone's weight.

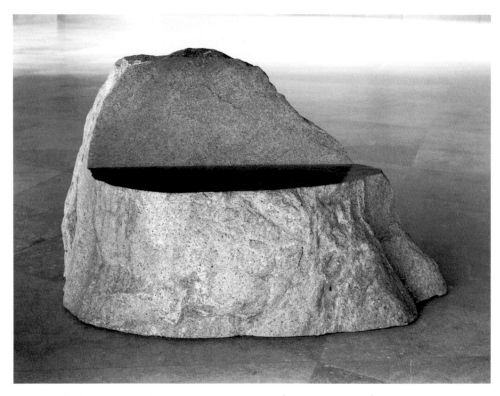

63. Scott Burton (American, 1939–1989), *Rock Settee*, 1988. Pink granite, 38½ x 63 x 42½ in. (97.8 x 160 x 107.9 cm). National Gallery of Art, Washington, D.C. Gift of the Collectors Committee

However, there are also several noteworthy ways in which they are anything but functional chairs. First of all, the stone is so heavy that, in order to safely accommodate *Rock Settee* (plate 63) within the average house or apartment, the floor would probably have to be reinforced—something one wouldn't expect to do for even the bulkiest recliner. Then there is the issue of comfort. In recent decades, designers have produced chairs that feature an astonishing variety of colors, materials, sizes, and especially shapes. Burton's "chairs" offer no such challenges, but—once seated—an individual will notice the hard, unyielding surface, and—especially in cold weather—the frigid temperature. It is difficult to imagine anyone pulling up a chair like this to the family's dinner table—assuming one could manage to move it at all.

So despite their welcoming titles, forms, and proportions, the weight, hardness, and coldness of the rock chairs all seem to disqualify them as furniture. Then are they sculpture? I think so, and—so far as I know—Burton is universally classified as a sculptor, not a designer. But the ambiguity inherent in this work—an ambiguity that Burton clearly intended—is such that even art museums cannot agree on how they should be treated. For instance, the Philadelphia Museum of Art used to display one of Burton's rock chairs on its ground floor, next to a pillar by the east entrance. Having previously been encouraged to sit on other, similar Burton "chairs," I once started to lower myself into this one. Imagine my horror (as a professional art historian who regularly reminds her students never to touch art) when a museum guard rushed over to admonish me for treating a valuable piece of sculpture in such a cavalier manner. Needless to say, I never made that mistake again. However, when the Baltimore Museum of Art had a retrospective exhibition of Burton's works, including several chairs, I was amused to observe that visitors were alternately encouraged, or forbidden, to sit on the art, depending on which guard was in the room at the time.

The National Gallery of Art in Washington, D.C., takes the most effective approach to Burton's rock furniture that I have yet encountered. Just inside the main doors to I. M. Pei's East Building and directly across from the information desk, there is a glass wall looking out on a traditional Japanese garden. In a gesture that demonstrates both compassion and common sense, the gallery's staff decided that Burton's *Rock Settee* should be placed in front of that glass wall, so that weary museum visitors could sit there to contemplate the garden. The placement of this work, and the uniformly encouraging attitude taken by both guards and the volunteers who work at the information desk, imply that the National Gallery regards Burton's work as furniture. However, embedded in the polished stone floor right next to *Rock Settee* is the same kind of discreet label the museum provides for every artwork on display. Therefore, Burton's work is clearly considered a sculpture—albeit, of a very rare type: a sculpture that people are allowed to sit on.

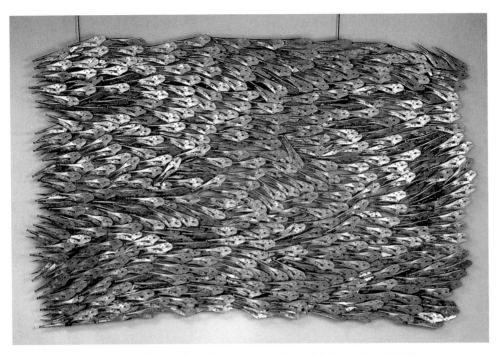

64. Arman (French/American, born 1928), *School of Fishes*, 1982. Welded steel and vise grips, 64 x 96 x 3 in. (162.6 x 243.8 x 7.6 cm). Tools as Art: The Hechinger Collection, Washington, D.C.

Just as Samaras's and Burton's chair sculptures encourage viewers to see furniture, and art, from a fresh perspective, so do several sculptures made out of actual tools. A particularly fine example of bringing such objects from the everyday world into an art exhibition space is Arman's *School of Fishes* (plate 64). This visually complex work is essentially a relief sculpture made up of hundreds of vise grips (plate 65) cemented together in a tight, rectangular format and attached to a flat surface that allows the composition to be hung on a wall. Because the vise grips are all mounted at slightly different angles, their silvery metal surfaces catch the light differently. This in turn gives the sculpture a complex texture and a quick visual rhythm, as though these were a school of small, shiny fish racing through a clear, shallow body of water or a fisherman's recent catch, spilled onto the ground at market (plate 66). Based on traditions established by Marcel Duchamp nearly seventy years earlier, Arman works

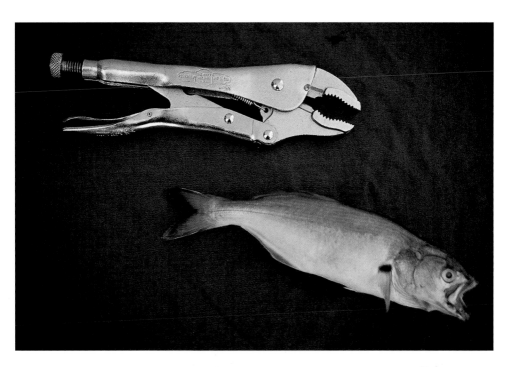

ABOVE
65. *Snappers* (vise grip and fish). Photograph by R. Gerard Regan

RIGHT
66. Graciela Iturbide (Mexican, born 1942), *Pescaditos de Oaxaca* (detail), 1992. Gelatin silver print, 8½ x 12½ in. (21.6 x 31.8 cm). Courtesy of Throckmorton Fine Art, New York

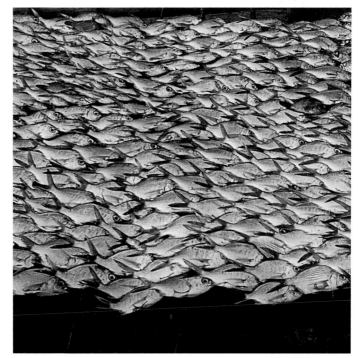

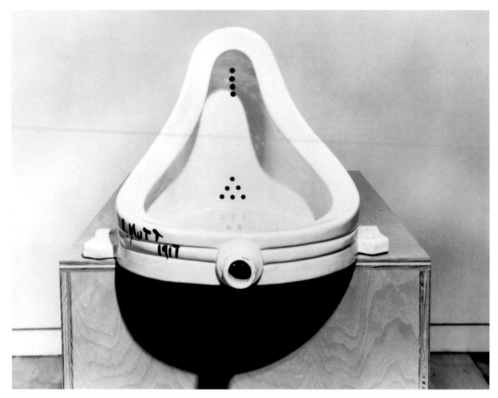

67. Marcel Duchamp (French, 1887–1968), *Fountain*, 1917/1964. Glazed ceramic with black paint, 15 x 19¼ x 24⅝ in. (38.1 x 48.9 x 62.6 cm). San Francisco Museum of Modern Art. Purchased through a gift of Phyllis Wattis

with "found" objects, transforming a humble tool into the image of a living thing. Arman's *School* has made me more visually aware than I had been before when I walk into a hardware store.

It is not only furniture (or, rather, sculpture that resembles furniture) that causes consternation among museum visitors. Unlikely as it may seem, there are even times when it is difficult to tell sculpture apart from plumbing fixtures. One of the most famous examples is Marcel Duchamp's notorious *Fountain* (plate 67), a standard-issue porcelain urinal that the artist turned upside down, signed (with the pseudonym "R. Mutt"), and dated (1917). *Fountain* is a quintessential embodiment of Dada, a radical approach pioneered by a group of European artists and intellectuals who found themselves in exile

amid the chaos of World War I. In a world where such barbarism could occur, they reasoned, there was no longer any point in adhering to the principles, traditions, or values with which they had been raised. In a series of humorous yet also nihilistic gestures, Dada artists systematically questioned even the most basic aspects of their respective fields. This resulted in some extraordinary creative breakthroughs, the effects of which are still felt today.[4]

On one level, of course, Duchamp's *Fountain* is simply a visual joke. When he originally submitted it (as a sculpture) to a New York City art exhibition in 1917, it was rejected on the obvious grounds that a urinal could not be considered art. Indeed, *Fountain* violates most traditional ideas about sculpture. It is (at least potentially) functional, since it could easily be connected to the pipes and water sources needed to make it work. Its apparent subject matter is so far removed from the usual realm as to be shocking, even disgusting, to most audiences; and the artist was not personally involved in fabricating, or even supervising the fabrication of, this piece. Duchamp didn't "create" this sculpture. Rather, he "found" it, already made (hence, the designations he made famous, of "found" art and "readymades"). What makes this a sculpture rather than plumbing, Duchamp maintained, was the fact that this particular urinal had been chosen by him for exhibition. Because he was a professional artist, he argued, his act of selecting and then designating this object as "art" transformed it into precisely that. Obviously, Duchamp didn't expect viewers to agree. In any case, Dada was not about creating works of art, in the traditional sense. Rather, it was a campaign to flout conventions, in deliberately outrageous ways that were intended to reveal the essential meaninglessness of modern life and to shock viewers into reexamining, and reevaluating, their world.

As ambitious as Dada was, Duchamp never intended for people to be reverently contemplating his *Fountain* in art museums and college classrooms almost a century later. The point is that *Fountain* was not a sculpture. It was always the ideas behind the gesture of calling it a sculpture that mattered most

to Duchamp. And those ideas have become an integral part of modern thinking about art.[5] *Fountain*, in fact, inspired several generations to make their own sculptures based on plumbing. But these younger artists have chosen to use the forms of urinals, toilets, bathtubs, and sinks to make very different points. For instance, the California-based sculptor Robert Arneson fashioned small commodes out of multicolored glazed clay as part of his series emphasizing the funkier side of everyday life. Like Oldenburg (whose *Soft Toilet* we saw in chap. 6), Arneson elevates a particularly banal element of daily existence to the status of sculpture. At the same time, he also forces viewers to consider the nitty-gritty details of the use that toilets serve. More recently, the British sculptor Rachel Whiteread has produced full-size sculptures of bathtubs, using plaster or colored resins to make casts from actual tubs. However, because of their colors and textures, as well as the lack of pipes and other mechanical necessities, no one could mistake Whiteread's works for actual plumbing fixtures.

One of the hottest artists of the last two decades has been the American Robert Gober, who has made a number of different plumbing-inspired forms, including several versions of both sinks and urinals (plate 68). Gober's urinals look much closer to the real thing than comparable sculptures by Arneson, Oldenburg, or Whiteread, but they are not "found," like Duchamp's. Gober fabricates these works from a variety of materials and then typically mounts them on a gallery or museum wall, often at the height where actual urinals would be found in a men's room. From a distance, these seem smooth and industrial, like real urinals, but their handmade qualities become clear at closer range. However, because they are the same size, shape, and color as actual urinals, Gober's sculptures are more likely to be confused with real plumbing—at least, at first glance—than almost all the works mentioned above.

Ultimately, the absence of pipes or water, and—most obviously—the location of Gober's works in a public space, keeps viewers from accidentally mistaking these for real urinals. People can identify them as sculpture with relatively little difficulty.

68. Robert Gober (American, born 1954), *Two Urinals*, 1986. Plaster, wire lath, wood, and semi-gloss enamel, 19 x 16 x 14 in. each (48.3 x 40.6 x 35.6 cm); 19 x 47 x 14 in. overall (48.3 x 119.4 x 35.6 cm). Courtesy of the artist

69. Carl Andre (American, born 1935), *Zinc-Magnesium Plain*, 1969. Zinc and magnesium, 72 x 72 x ⅜ in. (183 x 183 x 0.4 cm). The Baltimore Museum of Art. Fanny B. Thalheimer Memorial Fund, BMA 1988.68

Yet in extreme cases it may be almost impossible to tell where the "art" is in a given situation—or even to realize that there is any art present at all. This is especially true when works are displayed in settings—or in ways—not normally associated with art. For example, you wouldn't expect to see art on the floor. Admittedly, lots of sculptures are exhibited on pedestals that, in turn, rest on the floor. But generally the sculpture itself is elevated well above the surface on which visitors walk. But since the 1970s a number of nontraditional sculptors have made "floor pieces"—artworks that are displayed right on top of the gallery or museum floor. This forces viewers to change their focus and poses a number of new questions about the essential nature of sculpture.

Much of Carl Andre's work (such as the example illustrated in plate 69) consists of thin metal squares laid flat on the floor of an exhibition space. Andre does not fabricate these squares; they are "found" (or, more accurately, purchased). Nor does he personally supervise the laying down of the squares; sometimes an assistant does this, following diagrams made by the artist. In all cases, however, Andre ensures that the squares are arranged in the precise place and pattern he has determined. These are temporary, site-specific sculptures that can be surprisingly beautiful (although photographs, especially black-and-white ones, invariably mask the aesthetic interest inherent in such works). Andre's floor pieces look different from every angle, as the light catches various parts of each square, revealing unexpected colors and textures. Different works in this series also create distinctive visual patterns on the floor—some of Andre's works are symmetrical, whereas others feature irregular edges, creating a dynamic overall design.

Of course, before you can appreciate one of Carl Andre's works, you have to notice that it is there. To do so, first you need to look down (a direction you might not expect to yield anything of interest). Then you must also recognize that the metal squares are part of the exhibition and not, say, construction materials. Who would expect to find art on the floor? In a case like this, it sometimes takes a while to think of looking for, and then to locate, the museum label that lets you know this is, in fact, part of a display.

"One of the reasons people cannot bring themselves to appreciate Minimal art is that they do not consider that a row of styrofoam cubes, or firebricks, can be art at all. They see no evidence of the artist having done any 'work,' and consequently, they quite sincerely believe that they are dealing with a gigantic fraud which has been allowed to spread its ramifications over the whole of Europe and America."

Suzi Gablik, 1980

It can be remarkably tough to identify certain artworks even within a conventional museum setting. Several years

ago I was invited to give a lecture at the Baltimore Museum of Art on a selection of their recent acquisitions, all relatively new examples by important avant-garde artists. As part of my preparations, I took a trip to Baltimore and walked through the museum's marvelous modern art wing, taking notes about each piece on my handy checklist. After a few hours I had figured out what I wanted to say about all but one of the twenty-odd pieces in question. However, try as I might, I simply could not locate the work on my list by Jenny Holzer. I was familiar with Holzer's art, which typically involves composing a group of aphorisms and then displaying them as printed posters, as LED electronic signs, or carved on the tops of stone benches. But I hadn't seen anything like this in the museum, and since I was the Outside Expert who had been hired to explain this strange new art to other people, I was too embarrassed to ask a guard to find the Holzer piece for me.

Finally, as I was ready to give up and go home in disgrace, a small cast-bronze plaque happened to catch my eye (plate 70). I had noticed it earlier, but—assuming that it was just a standard sign of some sort—I had walked right by, without giving it a second glance. Mind you, this plaque had the same sort of color, texture, shape, size, and font that characterize the historical markers you see on old buildings and other noteworthy sites. Moreover, it had been mounted—as historical markers generally are—on the wall at eye level. These facts, and the location of the plaque—in a small, cramped, dimly lighted area of the museum's second floor, half-hidden behind a pillar and next to the elevator—all seemed to indicate that it was relatively unimportant, something that the museum's designers realized had to be there but that they were trying to downplay.

When I went back to look again, I discovered that this plaque was one of Holzer's "signs." Its label was particularly hard to find, but the text of the plaque itself gave everything away. Instead of acknowledging someone's financial support, or describing the evolution of that wing, the plaque read, "It can be startling to see someone's breath, let alone the breathing of a crowd. You usually don't believe that people extend that

IT CAN BE STARTLING TO
SEE SOMEONE'S BREATH,
LET ALONE THE BREATHING
OF A CROWD. YOU USUALLY
DON'T BELIEVE THAT
PEOPLE EXTEND THAT FAR.

70. Jenny Holzer (American, born 1950), *Selection from "The Living Series,"* 1980–82. Cast bronze, 6 x 10 x ⅜ in. (15.2 x 25.4 x 1 cm). The Baltimore Museum of Art. Friends of Modern Art Fund, BMA 1991.99

far." Pure Holzer—and obviously *not* a historical plaque. Equally typical of this artist's work was the game of hide-and-seek I had had to play to recognize her plaque as "art." After this discovery, I felt somewhat foolish, but ever since then I find myself looking far more carefully at every bronze plaque I pass. Through her work, Holzer—like Arman and Andre—has made me more aware of my surroundings.

In the end, it is precisely this process that makes art— whether traditional or avant-garde—so exciting to those of us who are not artists. When we are lucky enough to encounter works of art that "speak" to us, that experience can affect more than just the way we approach other gallery and museum encounters. Thereafter, as we go about our daily lives, we can sometimes see the world through someone else's highly sensitive eyes. As Marcel Proust noted, "Only through art can we get outside of ourselves and know another's view of the universe which is not the same as ours, and see landscapes that would otherwise have remained unknown to us."[6]

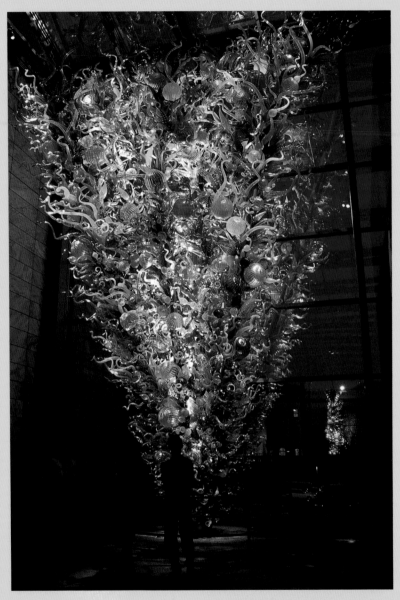

71. Dale Chihuly (American, born 1941), *Chihuly: Inside & Out,* 2000. Glass, 33 x 22 (at top) x 8 ft. (10.1 x 6.7 x 2.4 m). Joslyn Art Museum, Omaha, Nebraska

THE EMOTIONAL IMPACT OF (SOME) ABSTRACT ART

8

"If you let your eyes stray over a palette of colors, you experience two things. In the first place you receive a purely physical effect, *namely the eye itself is enchanted by the beauty and other qualities of color. You experience a satisfaction and delight, like a gourmet savoring a delicacy. . . . And so we come to the second result of looking at colors: their psychological effect. They produce a correspondent spiritual vibration. . . . Generally speaking, color directly influences the soul."*

Wassily Kandinsky, 1912

I T'S EASY TO UNDERSTAND how a representational artwork can evoke strong emotions. Even without knowing anything about the Napoleonic invasions of Madrid, someone looking at Goya's *Third of May, 1808,* can clearly tell that it concerns political repression and death. Likewise, a Madonna painted by Raphael (plate 9, for example) conveys a sense of serene faith to Catholics and non-Catholics alike. It may be harder to accept that abstract art (whether stylized or totally nonrepresentational) can also have a profound emotional impact. But it can.

Of course, in order for this to occur, viewers have to be open to the possibility of finding beauty, joy, anger, and other emotions within an abstract artwork. Too often, people dismiss abstraction because they do not believe that they can respond to it on a personal level. This is not surprising, since most Americans are raised—by our families and our teachers—to approach works of art by first trying to figure out what they are "of." From a very early age, we learn to evaluate other people's art, and our own, by how easy it is to identify the subjects of that art. If a toddler's mother can immediately tell that her crayon drawing represents a horse, then it must be good. As adults, we tend to apply the same criterion. Thus, if we cannot tell what a particular painting is of, we often assume that it is not a very good painting. Neither of the alternative assumptions—that we aren't very good at identifying the subjects of paintings or that the artist is making fun of us by only pretending to include an identifiable subject—is very appealing. It is no wonder, then, that so many people feel uncomfortable around abstract art.[1]

However, if you can relax and forget about whatever you believe you are supposed to see in a work of art, you may experience a surprising range of emotions, including pure pleasure. It should not be difficult to accept that an abstract painting— even a totally nonrepresentational, monochrome painting—can be a source of pleasure. After all, as noted earlier, many people have a favorite color that makes them feel particularly good when they wear clothing, drive a car, or sit in a room of that par-

ticular hue. Color may affect people in various ways for a whole host of conscious, and unconscious, reasons, but there's no doubt that they do respond to it on an "abstract" level.

People often listen to music—a famously abstract art form—in order to enhance, or sometimes to erase, certain emotions. Individuals may respond differently to the same piece of music, but virtually everyone can identify certain instrumental or vocal works that make them feel joyful, peaceful, or angry. It is the same with visual art. For some viewers, a particular abstract painting may be annoying, while others find it conducive to silent meditation, and still others derive sensual excitement from looking at it. The potential emotional power inherent in a work of art is analogous to that found in a landscape. Many people travel long distances simply to be able to sit and gaze at a view they love. For some, merely contemplating a body of water—whether the ocean, a lake, or a man-made fountain—can drive away stress and induce euphoria. Moreover, people can look at the same body of water, day after day, season after season, year after year, and feel a new sense of excitement and well-being every time. This holds true even when there is nothing specific (such as a passing boat, a storm, or a flock of birds) to see.

Just as people find favorite landscapes to look at, so do many people develop a lifelong fondness for a particular artwork, which affects them just as strongly as any ocean view. At one art museum where I worked, I noticed an abstract painting, a rectangle of shimmering colors, that never failed to put me into a better mood after I had looked at it for a few moments. On difficult days, I would devise reasons to walk through that part of the museum, just so I could spend a little time in front of the painting.

Of course, pleasure is not the only emotion that can be experienced through abstract art; humor is another. Humor is seldom associated with sculpture of any kind and especially not with abstract sculpture. Yet much of the work by Julio González, for example, is actually quite funny. After a long and successful career as a specialist in ornamental ironwork, the

Catalan artist began working full-time as a sculptor in 1928, at the age of fifty-two. Although he was following both a family tradition and a regional one by working primarily with iron, he departed dramatically from those traditions by making metal art that was neither functional nor realistic. At first glance, his witty images of drastically simplified men and women seem totally abstract. But González's titles (such as *Woman Combing Her Hair*, plate 72) direct our attention to certain human characteristics—in this case, the saucy curve of the woman's back and the windswept lines that represent her flowing tresses. González used pieces of metal as gestures, the same way an Abstract Expressionist painter might use individual brush strokes. As a

result, his art has lots of implied motion, a quality seldom associated with iron.[2]

Both the formal qualities and the types of humor found in Alexander Calder's art are quite different from the sculpture made by Julio González. Best known for his mobiles (plate 54), the Philadelphia native also created an enormous number of "stabiles," so called because they do not move. These stabiles range in size from tiny to huge, but all of them share with Calder's kinetic sculpture his interest in simplified forms, references to nature, solid primary colors, and sheer fun. Many young children become obsessed with the subject of dinosaurs. But children and adults alike can delight in Calder's *Stegosaurus*

(plate 73), a fifty-foot-tall, bright red steel sculpture that has dominated a plaza in downtown Hartford, Connecticut, for the past thirty years.

The unlikely juxtaposition of this whimsical piece of public art with the sober office buildings of this city most closely associated with the insurance industry makes *Stegosaurus* even more amusing. As usual, Calder has grossly simplified the anatomy of his subject, merely suggesting the size and strength of this herbivorous dinosaur via a pair of simple arched forms, topped by several projections representing the row of spines that run down the back of an actual stegosaurus. This design allows passersby to see—and walk under—the arches, while the elegant curves of the spines parallel the circular fountain below. From a distance, Calder's stabile resembles both a prehistoric beast and some exotic tropical plant with gargantuan fronds. Yet its title makes clear the relationship between this huge piece of metal and its prehistoric namesake.

There is no way a viewer could guess the title of Franz Kline's painting entitled *New York, N.Y.* (plate 74) simply by looking at it. Nor is there anything particularly funny about this large, Abstract Expressionist canvas. Nevertheless, it is relatively easy to respond emotionally to the sense of speed, drama, and raw power generated by this black-and-white abstraction. Around 1950 Kline developed the signature approach seen here: broad, slashing marks made with an unusually wide paintbrush. Like New York City itself, this painting positively radiates energy because of the large, aggressive forms and the strong contrast between colors. The vitality of the composition comes partly from the asymmetrical placement of the marks and Kline's stress on diagonal forms. Moreover, it is easy to imagine the quickness with which the artist moved his brush and the physical effort required to do so on such a large scale. Unlike most realistic artworks, which generally elicit the same sort of response from each viewer, an abstract painting like Kline's (or one of Pollock's poured canvases; see plate 7) gives every viewer the latitude to respond in his or her own way.

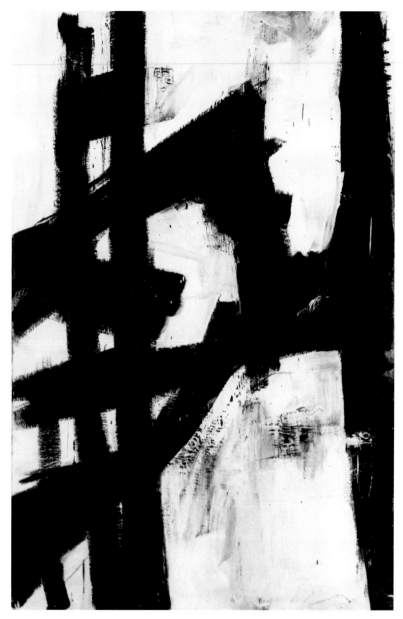

74. Franz Kline (American, 1910–1962), *New York, N.Y.*, 1953. Oil on canvas, 79 x 50½ in. (200.7 x 128.3 cm). Albright-Knox Art Gallery, Buffalo. Gift of Seymour H. Knox, Jr., 1956

"Painting isn't just the visual thing that reaches your retina— it's what is behind it and in it. . . . I paint this way because I can keep putting more things in it— drama, anger, pain, love, . . . my ideas about space. Through your eyes it again becomes an emotion or an idea. It doesn't matter if it's different from mine as long as it comes from the painting which has its own integrity and intensity."

Willem de Kooning, 1951

Obviously, not all abstract works express humor or raw, aggressive power. Yet it is equally possible to respond emotionally to more subtle aesthetic qualities—as demonstrated in the following four sculptures. Each one is very different from the others, but all are nonrepresentational and share a common focus on beauty. More specifically, these sculptures all deal with light and with the extraordinarily varied, even magical, ways light can affect—and be affected by—various colors, materials, and forms.

Nothing seems less promising than neon lighting as a source of pure aesthetic pleasure. Neon is far more likely to be associated with "tacky"—signs advertising cheap eateries or, in its most highly evolved form, the famed Las Vegas strip. Yet during the 1960s a number of sculptors—including Bruce Nauman, Chryssa, and Dan Flavin—began exploring the potential of neon as a medium for fine art. Some of these works involve colored, luminescent tubes that form actual words, which are closer to Jenny Holzer's LED aphorisms than to actual signs. Others, most notably Flavin's evocative works, use both color and light to transform architectural spaces in unexpected ways.

In *Untitled* (plate 75), Flavin mounted three four-foot-long fluorescent tubes (only one of which is clearly visible in reproductions) horizontally, across the corner of an art gallery. Flavin didn't construct these tubes; on one level, the piece is meant to remind viewers of the ubiquitous, industrial-type lighting seen in offices. However, instead of a neutral whitish color, Flavin's sculpture emits pink, blue, and green light, and also creates green and purple shadows on the wall. Moreover, rather than

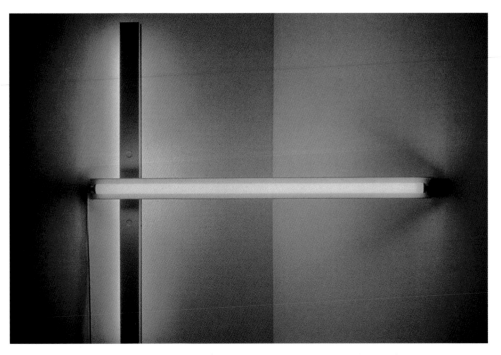

75. Dan Flavin (American, 1933–1996), *Untitled*, 1974. Pink, blue, and green fluorescent light, 48 in. across a corner (121.9 cm). Courtesy of Leo Castelli Gallery, New York

hanging from the ceiling, Flavin's piece is positioned roughly midway between the ceiling and the floor. Because there is only one set of tubes (instead of the multiple fluorescent lights typically seen in a workplace); because it has several colors; and because it spans the corner of a room, viewers tend to see this as a discrete form: a sculpture. Furthermore, if one can stop wondering why materials normally associated with illuminating artworks—rather than being the artworks themselves—are used here, one can revel in the marvelous mixtures of colors splashed across the walls. Peter Selz described Flavin as "painting in colored lights,"[3] and other critics have pointed out the environmental nature of Flavin's work, which does indeed transform the space surrounding the actual tube. In addition, there is the matter of the specific colors of Flavin's light, each of which can evoke different emotions in different viewers.

Glass is just as intriguing a medium as light. This material is at once brittle and strong; transparent, translucent, or even opaque, depending on how it is made; and capable of being blown, molded, or fused into a seemingly infinite variety of shapes. People have been working with glass since ancient times, but the twentieth century marked the emergence of glass artists known for producing nonfunctional works that overcame the traditional label of craft to be regarded as true sculptures. One of the best-known contemporary glass artists is Dale Chihuly. This Seattle-based sculptor has done as much as anyone to transcend the limits of glass, creating organic yet abstract forms that allude to seashells, flowers, and bubbles. Chihuly has also produced dramatic installation pieces—entire walls, ceilings, and windows made of richly colored, fantastically curving glass. *Chihuly: Inside & Out* (plate 71) is a spectacular work, exploding upward from a narrow base and extending more than thirty feet into the air. This sculpture seems to violate the law of gravity; it also gives the illusion of constant movement and metamorphosis, as though every piece of glass were still being formed and then sliding into a new relationship with all the others.

"I was looking at all these color rods, these 300 different color rods that make up our palette for glassblowing. They come from Europe, mostly from Germany. And at that point, I had probably only used 10 or 20 percent of these colors. I woke up one morning in 1981 and said, 'I'm going to use all 300 colors in as many possible variations as I can.'"

Dale Chihuly, 1992

In sculptures like this, Chihuly starts with the simple pleasure that everyone has experienced in watching a ray of sunlight filter through a window, a flower vase, a fishbowl, or a stained-glass window. The artist then intensifies all the sensory data involved in such experiences. The riot of colors in plate 71 is typical of this artist's work and easy to see even in a photograph. What may not be fully apparent from a reproduction, however, is the variety of effects produced by the many kinds of light that

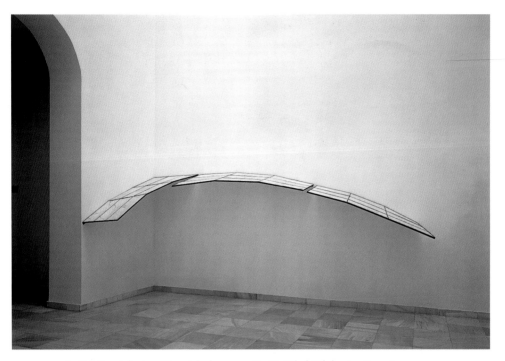

76. Cristina Iglesias (Spanish, born 1956), *Untitled (Alabaster Room)*, 1993.
Iron and alabaster, three parts, dimensions variable. Installation view,
Museo Nacional Centro de Arte Reina Sofía, Palacio de Velázquez, Madrid.
Collection Guggenheim Museum, Bilbao

fall onto this work—most obviously, sun and moonlight—from
the enormous window next to it, plus the electric lights trained
on it by the museum's exhibition designers. Then there are the
reflections—of the sculpture in the windows, and the windows
on the sculpture, as well as the way the myriad colors appear to
blend and change as the viewer walks around the work.

The mysteries, and the glories, of translucency and the
transformation of industrial materials into sculpture are equally
apparent in the iron-and-alabaster sculptures by Cristina Igle-
sias. Like much of her earlier work, the series to which plate 76
belongs has obvious ties to architecture. However, while these
untitled works resemble fragments from some larger, unidenti-
fiable structure, they also seem complete in themselves. They
create their own spaces and confound our expectations, as the

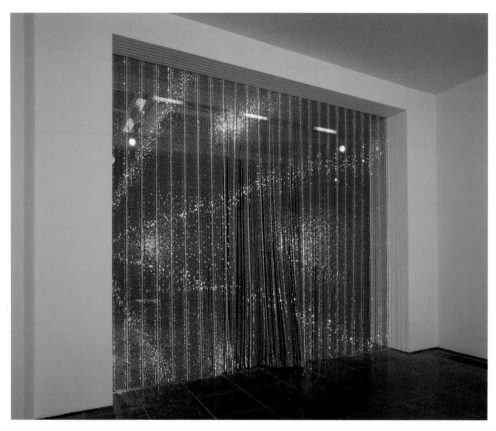

77. Félix González-Torres (Cuban/American, 1957–1996), *Untitled (Water)*, 1995. Plastic beads and metal rod, dimensions vary with installation. Installation view, Serpentine Gallery, London, *Félix González-Torres*, June 1–July 16, 2000. The Baltimore Museum of Art. Purchase with exchange funds from Bequest of Saidie A. May, BMA 1995.73

heavy metal forms—set with slices of stone—appear to float above the museum's floor. Yet the truly remarkable aspect of Iglesias's wing-like sculptures is their old-fashioned beauty, as the light is diffused softly through the alabaster (a material used for windowpanes in some medieval churches), casting intriguing shadows on the wall.

In chapter 6 we saw one of the many ways in which Félix González-Torres encouraged viewers to interact with his sculptures, by taking some of the wrapped candies from his *Untitled (Portrait of Ross in L.A.)* (plate 57). Plate 77 illustrates another,

related example. Here, the artist has again challenged the usual prohibition against touching art. But, as in much of his work, González-Torres has produced a piece that also engages virtually every sense. On one level, *Untitled (Water)* simply looks like a beaded curtain, an inexpensive room divider made of plastic beads—the sort of thing favored by counterculture collegians in the late 1960s and early 1970s. It actually is a kind of veil made of plastic beads—ordered, not fabricated, by González-Torres and serving to separate one space from another.

This work by González-Torres again contains a number of autobiographical references—mainly to the colors of the various intravenous fluids used to treat both the artist and his partner during their struggles with complications from AIDS. However, this personal component is in no way evident from either the appearance of the work itself or its title. In fact, even though a knowledge of its subtext inevitably adds an element of empathy to the viewer's experience, *Untitled (Water)* also stands perfectly well on its own, apart from its symbolic content, as a tremendously rich, sensual experience.

No less than fluorescent tubing, blown glass, or alabaster, González-Torres's plastic beads catch, bend, soften, and reflect the light—both natural and artificial—that falls on them from windows and electric fixtures. Because the beads are faceted, like gemstones, and also transparent (or translucent), they sparkle as the closely spaced vertical strands move gently when ruffled by the artificial breeze of an air conditioner or swing violently when a visitor walks through them. The overall shape of the bead curtain is variable, as are its dimensions. The former changes depending on whether the curtain is relatively static or responding to visitor traffic; the latter vary according to the width and height of the opening where the curtain hangs. The colors of the beads also vary, within a narrow spectrum of blues, silvers, grays, and clear beads that appear almost white. Since each individual strand is exclusively one color, and since the colored strands are arranged in a carefully determined pattern, the total effect of this piece is analogous to that of one of the vertical stripe paintings discussed in chapter 3 (see, for example, plate 18).

Part of the fun of seeing one of González-Torres's bead curtains in a public exhibition space comes from watching other visitors deal with these unexpected objects, but it can be even more satisfying to experience them for yourself. After an initial uncertainty—since it is difficult to tell if such a curtain is simply a decorated doorway or part of the exhibition—visitors may feel a delicious sense of naughtiness when they realize that the only way to move into the next room is through the curtain, even though that curtain is, indeed, one of the artworks on display. After hesitating, a visitor may walk through the curtain slowly or quickly, confidently or with trepidation. From a distance the plastic barrier allows you to see into the next room, but indistinctly, through a screen of color. As you approach the curtain, you feel the weight of the strands on your clothing and your bare skin. Finally, there is the soft clicking sound the beads make as they rub against each other, and the shapes the moving strands make as they fly back and forth through the air, continuing to swing long after you have moved on.

There is nothing inherently exciting about walking through a curtain made of plastic beads. But what González-Torres has done is to provide an opportunity for the interested viewer to observe carefully, and to think about, the many dimensions involved in interacting with these colored forms. In so doing, the artist has made it easier for us nonartists to slow ourselves down long enough to be able to experience—in exquisite detail—a perfectly ordinary process that becomes quite extraordinary due to the artist's, and our, willingness to put time and effort into savoring every aspect of it.

Just as each museumgoer may have a different response to a painting by Franz Kline, so each visitor will respond differently to González-Torres's beads. Some will luxuriate in the encounter. Others will essentially ignore the work, concentrating on moving from one room to another. This range of responses is both inevitable and perfectly fine, since everyone's imagination is piqued by different sorts of experiences. The key to enjoying the largest possible number of types of artworks is to try to see as much art as you can, with as open a mind as possible.

One excellent example of an ordinary object rendered extraordinary by an artist's way of looking at and presenting it comes from the film *American Beauty*, a dark satire about severely dysfunctional families in a modern-day U.S. suburb. The "beauty" in its title refers, in part, to the red American Beauty roses that are a recurring visual motif linked to an attractive high-school cheerleader. However, there is another surprising yet equally powerful element of beauty in this film. At one point a troubled young man whose only pleasure in life seems to come from filming the girl next door shows her his videotape collection. His favorite sequence, he says, is one that focuses—literally—on a piece of trash: a small, empty, clear plastic bag of the sort that grocery stores provide for carrying fresh produce, which someone has carelessly discarded. This doesn't sound like a very interesting subject for a film, but as a breeze sweeps down the empty street the bag flutters and twirls, soaring and diving through space in an unpredictable dance that is utterly captivating.

The purpose of that segment was to demonstrate that beauty can sometimes be found in the most unexpected places. Likewise, a major goal of this book is to convince you that it is worth taking the time to go see even the exhibitions that you suspect you might not enjoy. Visual art is unpredictable too, and the only way to be certain of your opinion is to see the work for yourself. Moreover, as the deceptively simple-looking interactive sculptures by González-Torres make clear, you will get the most enjoyment from a museum or gallery visit if you take a deep breath, relax, and give a few of the works a chance to move you. Rather than rushing off to try to take in every work in a large exhibition or the entire contents of a museum wing, sit—or stand—still for as long as you can manage it and concentrate on the one or two examples that interest you the most within a particular room. Try to figure out exactly what it is that you like, or dislike, about the art in question. This is the kind of dialogue that artists have with their own work. It should also make the art-viewing experience both richer, and less daunting, for nonartists.

78. Chris Cassatt and Gary
Brookins, "Jeff MacNelly's Shoe,"
10 December 2000

COMMONSENSE ANSWERS TO SOME OF THE QUESTIONS MOST OFTEN ASKED ABOUT MODERN ART

9

DIFFERENT PEOPLE OBVIOUSLY ASK different questions concerning individual works of modern art. On the whole, however, there seems to be remarkable agreement about the types of things most art observers want to know. What follow are eight of the questions I have been asked most often during and after the lectures and museum tours I have given over the past twenty-some years. The answers are not intended to provide in-depth analyses of what, in certain cases, are tremendously complicated matters. Still, I hope they will be a useful starting point.

QUESTION 1: *How Can You Tell Whether That Thing in the Corner Is a Modern Sculpture or the Humidity Monitor?*

SHORT ANSWER
Sometimes you can't—which may be the artist's point.

Most professional exhibition spaces that can afford them place humidity monitors in at least some of their rooms. This is because the level of moisture in the air significantly affects the artworks on display (as do the temperature, ultraviolet light, and other environmental factors). The humidity level is particularly important for works on paper (drawings, prints, photographs, collages, and so on), which are surprisingly fragile; but it can also threaten other types of art and must be closely watched.

There are various models of humidity monitors, but most tend to be rather plain, dark, rectangular boxes with some sort of moving pointer that records the level of humidity on a roll of paper. Since no one wants them to compete visually with the artworks on exhibition, humidity monitors are generally located in inconspicuous places—on the floor, in a corner of the gallery, or at one edge of a display case. Nevertheless, since abstract sculpture—especially Minimalism—often takes a simple, box-like form (see, for example, plate 79), it is quite possible for a viewer to confuse the two types of objects.

This kind of confusion between art and object eventually happens to everyone who spends time around contemporary art. In fact, that uncertainty is actually the goal of some artists, who create nonfunctional works that deliberately mimic objects from the real world. During the 1980s, for example, the American sculptor Jeanne Silverthorne became known for her cast-rubber versions of various objects, including chandeliers and—my personal favorite—an exit sign. The latter was displayed near the ceiling of Philadelphia's Institute for Contemporary Art, right next to the real exit sign, during Silverthorne's one-person exhibition there. Since her sculpture was the same size, color, and general shape as the actual sign, I did a double take when I first saw it. However, I soon realized that there wouldn't be two exit signs mounted, side by side, on the same wall. Some additional sleuthing revealed that Silverthorne's sign looked slightly different—a bit softer around the edges—from the other one and also that it had its own wall label (a definite giveaway).

79. Richard Serra (American, born 1939), *One Ton Prop (House of Cards)*, 1969. Lead antimony, four plates, 48 x 48 in. each (122 x 122 cm). The Museum of Modern Art, New York

Why would an artist bother to create something that looks so much like a commercial sign, which in turn resembles countless other such signs, all of which were mass-produced in some factory? Largely for the same reason that Jenny Holzer made bronze plaques intended to resemble historical markers (plate 70), or that the sculptors mentioned in chapter 7 made their own versions of furniture or plumbing fixtures. The frequency with which contemporary gallery and museum visitors must deal with these issues, and the continuing discomfort that many people feel as a result, has been spoofed in a large number of recent comic strips (plate 78).

One of the goals of such sculptures is precisely to stop us viewers in our tracks, to make us momentarily question the distinction between "art" and "life"; to force us to spend a little more than a few seconds studying their work; and—ultimately—to transform our vision of the world.

QUESTION 2: *How Long Did It Take to Make This Artwork?*

SHORT ANSWER
Longer than you might think.

LONG ANSWER
When someone asks my father, Jules Heller, how long it took him to create one of his monotypes (plate 80), he answers, "Three hours, and eighty-two years." This sounds like a throwaway line, but it is actually a rather profound answer. In order to understand the implications of this statement, it is first necessary to know a little bit about monotypes. A monotype is a printing process that yields only one original work. This is different from the more familiar printmaking techniques, such as woodcut, etching, and serigraphy (silkscreen), which an artist uses to make an edition of a certain number of prints, each one of which looks exactly the same as all the others, and each of which is a true original.

To produce the kinds of monotypes that he has been making since the 1980s, my father starts by covering a thin, rectangular plastic plate with printer's ink, to which he sometimes adds additional texture by shaking on drops of a solvent, which dissolves the colored ink, leaving irregular spots of white. He then uses pastels to draw on tracing paper, which he has torn into small shapes. Next, he carefully places the paper fragments onto the wet plate, creating a composition that he finds pleasing. After a few more steps, the plate is put onto the bed of a printing press. Then a sheet of dampened paper is laid on top of the plate and the whole thing is pulled through the press, so that the image (made by the paper, pastels, and ink) will be transferred onto the paper—only backward, so that the finished design is the reverse of what he had originally arranged on that plate. The paper is slowly peeled away and allowed to dry. Because there is no longer much ink left on the plate, the same print cannot be "pulled" again. That is why this sort of print is called a "monotype," as opposed to etchings, lithographs, or silkscreen prints, which are "multiples."

The point, here, is that the physical process of composing

80. Jules Heller (American, born 1919), *Beastie*, 1982. Monotype, 22 x 30 in. (55.9 x 76.2 cm). Private collection of Leif Magnusson and Charlotte Sibley, Plainfield, New Jersey

and pulling the monotype takes approximately three hours. However, my father is able to accomplish this so quickly only because of the lifetime he has spent familiarizing himself with printmaking techniques and because of his extensive experience with making interesting designs on the spot. Similarly, a traditional Chinese brush painting (plate 81) takes only a short amount of time to make. Yet the artist spends many years acquiring the technical expertise needed to make each bamboo leaf look real, for example, while incorporating it into a graceful composition. As with classical ballet, competitive ice skating, or nearly any other physical skill, the artist must work tremendously hard, for a long period of time, to make what she does appear effortless and fluid.

Returning to an example from the Western world: in his

81. Xu Wei (Chinese, 1521–1593), *Twelve Flowers and Poems* (section 7), Chinese, Ming dynasty, 16th century. Handscroll, ink on paper, 1 ft. 1 in. x 17 ft. 7 in. (0.3 x 5.4 m). Freer Gallery of Art, Smithsonian Institution, Washington, D.C. Purchase, F1954.8

1878 libel suit against the critic John Ruskin, James McNeill Whistler had to deal with a similar misperception about art. Unlike his famous portrait of his mother, Whistler's *Nocturnes*— a series of misty, dark-toned, and evocative landscapes—are so stylized as to be virtually unrecognizable today, let alone in the nineteenth century. The British attorney general berated the artist by saying: "Now, Mr. Whistler. Can you tell me how long it took you to knock off that nocturne?" (a painting that previous testimony had established as having cost two hundred guineas, a substantial price for that time). Whistler responded that it had taken him two days to finish the painting. His inquisitor commented: "Oh, two days! The labor of two days, then, is that for which you ask two hundred guineas!" The artist answered: "No;—I ask it for the knowledge of a lifetime."[1]

In contrast to the techniques of monotype artists or traditional Chinese painters, the method used by Andrew Wyeth in works such as *Christina's World* (plate 82) is slow and painstaking. Moreover, Wyeth's painting looks as though it took a long

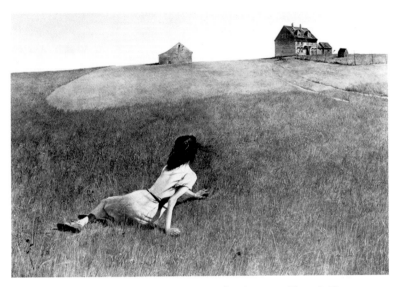

82. Andrew Wyeth (American, born 1917), *Christina's World*, 1948. Tempera on gessoed panel, 32¼ x 47¾ in. (81.9 x 121.3 cm). The Museum of Modern Art, New York. Purchase

time to produce. Even the most casual viewer can tell that it required many hours of concentrated effort to paint the individual blades of grass in the expansive field separating the crippled woman from her home. To produce that sense of hyperrealism for which he is so well known, Wyeth typically uses tempera rather than oil or acrylic paint. Tempera is avoided by most contemporary artists precisely because it demands such a deliberate working method; it is best suited for creating crisp, minute details rather than enormous, slashing brush strokes.

We live in a society that often thinks of value in terms of numbers—a higher hourly wage, for example, implies that the work being done is more important than lower-paid work. Likewise, many people assume that there is something especially valuable about an object that took a great deal of time to make, as opposed to something that did not. But art doesn't follow that rule.

QUESTION 3: *How Can You Tell Whether an Artwork Is Good or Bad?*

SHORT ANSWER
Learn everything that you can about art, but also trust your gut.

LONG ANSWER
The visual and performing arts are subjective to a degree that other fields generally are not. Unlike sports, where you can always tell who won the race, or mathematics, where the problem has just one correct answer, with art there is always room for more than one opinion. Different viewers respond differently to the same artwork due to certain intangible elements in both the art and the viewer. Moreover, this is true no matter what level of expertise the viewer may have, and art critics often vehemently disagree.

On several occasions, I have been invited to jury an art exhibition—that is, to help determine which of the entrants' works will be included in a particular show and also to decide which works will win prizes. I've always tried to be as even-handed as possible, looking for the "best" works in the bunch. Yet, inevitably, some of my own personal taste has come through. Judging an art exhibition—especially an open one, to which anyone may submit works in any medium, on any theme—is like judging a dog show. Connoisseurs may all agree on which animal should win the award for Best in Breed, but there is seldom universal agreement about Best in Show. It's not that one dog is literally better than another, especially since comparing different breeds is as difficult—and ultimately as impossible—as comparing apples and oranges, or abstract metal sculptures and realistic paintings. Rather, one particular dog—or a particular work of art—seems so exceptional that it outshines all the rest. While a judge—of dogs, visual art, chili, or anything else—can always justify his choice in rational terms, in the end much of this comes down to a highly unscientific "gut feeling." Nonetheless, when I've been part of an art-judging team, I have almost always been (pleasantly) surprised to discover that the other judges and I agree about which

Panel 1: WE WON THE BID TO CREATE A DIGITAL ARCHIVE OF THE WORLD'S GREATEST ART.

Panel 2: THIS WILL GIVE US A CHANCE TO FIX ANY ERRORS MADE BY THE ARTISTS. ERRORS?

Panel 3: FOR EXAMPLE, THERE WAS A GUY WHO USED TOO MUCH BLUE FOR A WHOLE PERIOD.

83. Scott Adams, "Dilbert," 6 August 1998

works are best. This seems to argue for some sort of universal goodness that transcends even the vagaries of individual taste. It may also reflect a set of basic assumptions about art, which jurors from similar cultural backgrounds are likely to share— even if they never actually discuss them.

If you're just trying to decide which artworks to take the time to go see, the answer is simple: see everything you possibly can, even if you don't think you are going to enjoy it. You can't know until you try. You can also take other steps to increase your exposure to various kinds of art and thus fine-tune your eye for judging it. These days, even small community art museums generally offer a whole host of educational opportunities for interested individuals. Consider taking a guided tour of an exhibition that interests you; sign up for an art history course at a local college or community organization; and don't forget to explore the resources available at your public library (a list of recommended readings appears at the end of this book). All these things should be both enjoyable and helpful in giving you the confidence to judge art for yourself.

THE HOT ONE HUNDRED

#	Artist	Note	#	Artist	Note
1	BRUCE NAUMAN	ALMOST all of it (90-95%)	51	TITIAN	Any featuring Monsters/dragons
2	SIGMAR POLKE	Paganini	52	JEAN DUBUFFET	Grungier ones
3	MIKE KELLEY	More Love Hours than can ever	53	DAVID SALLE	Porno ones
4	RICHARD PRINCE	Biker Girls/Jokes/Hoods	54	FIONA RAE	Whatever she's just done
5	ANDY WARHOL	Brillo boxes + Jackie O	55	KAREN KILIMNIK	TV Film Bad portraits
6	DONALD JUDD	Perspex+Metal Wall Pieces	56	RICHARD ARTSCHWAGER	Formica Furniture
7	J.M.W. TURNER	little boat in storm at sea	57	JEFF KOONS	V. Big Sculpture, New paintings
8	BRIDGET RILEY	B+W op art lines	58	ANDREAS GURSKY	MONTPARNASSE
9	KASIMIR MALEVICH	Monochromes	59	LARRY CLARK	Tulsa
10	MARCEL DUCHAMP	Fountain	60	ROSS BLECKNER	concentric circle white dots on black
11	JOSEPH ALBERS	Homage to square - colours	61	MICHAEL CRAIG-MARTIN	Biggest, brightest Wall drawing
12	AGNES MARTIN	small rectangles - subtle colours	62	DANIEL BUREN	Stripe constructions
13	PIET MONDRIAN	severest Hardedge stuff	63	RACHEL WHITEREAD	House
14	JASPER JOHNS	Flags + Alphabets	64	B+K BECHER	Water Towers
15	SOL LE WITT	Wall drawings	65	LAWRENCE WEINER	Letters carved into wall
16	ELLSWORTH KELLY	V. big squares of colour together	66	GARY HUME	Both Figurative + Doors
17	THOS. GAINSBOROUGH	Bad early Portraits	67	ROBERT SMITHSON	Hotel Tape / slide
18	MARK ROTHKO	Seagram Murals	68	NAN GOLDIN	Transvestite photos
19	ROBERT RYMAN	white on white !!	69	DUANE HANSEN	Jogger + tourists
20	FRANK STELLA	Grey line paintings	70	CINDY SHERMAN	Pigs snout
21	GILBERT + GEORGE	As themselves - shit + cunt	71	FELIX GONZALEZ-TORRES	Dancing queen + light bulbs
22	SEAN LANDERS	Text	72	ED RUSCHA	Funky word paintings
23	WILLIAM HOGARTH	Paintings not etchings	73	FISCHLI + WEISS	Carved studio junk
24	JACKSON POLLOCK	Long brown 'skilful' ones	74	ANDRES SERRANO	Ku Klux Klan pics
25	BARNETT NEWMAN	V. Big e.g. Voice of Fire	75	DAN FLAVIN	Circular Striplight arrangements
26	GERHARD RICHTER	Baader Meinhof	76	CHARLES RAY	Mannequins + Firetruck
27	JEAN-MICHEL BASQUIAT	Miles Davis Play List	77	RICHARD DEACON	Varnished cardboard with triangle
28	DAMIEN HIRST	shark + Dots	78	KIKI SMITH	Waxone from 'Some went Mad'
29	EL GRECO	Light on Face of Monkey	79	JOHN CHAMBERLAIN	Car Crash Sculptures
30	JULIAN SCHNABEL	Plates + Sail cloths	80	THOMAS RUFF	Single Portraits Head + shoulder
31		Frames	81	ANISH KAPOOR	Shiny Metal + Disc 7 Mountains
32	NIELE TORONI	Dabs on wall installations	82	RICHARD SERRA	heavy Metal
33	CY TWOMBLY	scribbles (Lot of it the same)	83	VICTOR VASARELY	Circle + Square coloured op
34	WILLEM DE KOONING	More abstracted less figurative stuff	84	LOUISE BOURGEOIS	Shiny bronze phallic stuff
35	JONATHAN LASKER	when doodle's big on plain background	85	ED KEINHOLZ	That bar you could walk into
36	LEON KOSSOFF	Swimming Pools	86	RENE MAGRITTE	Not a Pipe
37	CHRISTOPHER WOOL	Text with swearing or single words	87	RICHARD PATTERSON	Thomson shagging + Moto crosser
38	JOHN BALDESSARI	Hand Pointing + Instructions	88	NAM JUN PAIK	T.V. Pyramid with J. Beuys
39	GEORG BASELITZ	Upside down - white + yellow cheeks	89	ALLAN MCCOLLUM	Plaster Surrogates
40	PHILIP TAAFFE	More B+W/B+Colours Op Art ones	90	ALEX KATZ	V. big women's heads
41	JOSEPH BEUYS	Talking to Hare/Rabbit?	91	PAUL MCARTHY	Bossie Burger
42	BRICE MARDEN	Earlier Hard Edge strips of colour	92	MARTIN KIPPENBERGER	As a whole
43	PETER HALLEY	More the conduits than cells	93	EVA HESSE	Translucent Wall hangy/lean th...
44	CLAES OLDENBURG	Soft Sculpture + bedroom	94	FRANCIS PICABIA	Realist nude women
45	JEFF WALL	Steves Farm + Nosebleed	95	STEPHAN BALKENHOL	Tall Figures with carved plinth
46	ROY LICHTENSTEIN	Brush strokes	96	JESSICA STOCKHOLDER	when Wall is ripped out
47	MORRIS LOUIS	Corner Drips	97	MILTON AVERY	Coastal scenes
48	JULIAN OPIE	sculpture + wall drawing together	98	SARAH LUCAS	Sod You Cits, eggs, kebabs etc
49	JOHN MCCRACKEN	Planks	99	IAN DAVENPORT	Fine Line bright colour ones
50	CHUCK CLOSE	Recent Big portraits (Not realist)	100	IVAN HITCHENS	Bigger bolder brush marks (touching)

84. Peter Davies (Scottish, born 1970), *The Hot One Hundred*, 1997. Acrylic on canvas, 8 ft. 4 in. x 6 ft. 8 in. (2.5 x 2 m). The Saatchi Gallery, London

QUESTION 4: *How Much Is This Artwork Worth?*

SHORT ANSWER
Who wants to know?

LONG ANSWER
The worth of art various tremendously, depending on who you are talking to—and why. For instance, the Internal Revenue Service takes the matter of worth quite literally and allows an artist to deduct only the cost of materials (paint, brushes, canvas, stretcher strips, turpentine, etc.) from her taxes, when she donates one of her own works to an art museum. Paradoxically, however, the IRS allows private collectors to deduct the market value of the same work—that is, how much a buyer would be expected to pay for it at auction or through a commercial dealer. (Needless to say, virtually every work of art sells for much more than the cost of its materials; otherwise, the artist could never make a profit.) Collectors, not surprisingly, have been a lot more likely to donate their works than artists ever since this ruling took effect.

Anyone who has glanced at the price list discreetly placed on the receptionist's desk at a commercial art gallery has probably gasped in shock. How, one might wonder, can a single oil painting, by a reputable but not world-famous artist, be worth $25,000? Since art is not the same as other commodities, its price cannot be figured solely in terms of practical considerations such as the cost of materials, how long the artist spent making the painting, and so on. One oil painting may take several years for an artist to complete; no one could ever pay her enough to compensate for her effort, if figured solely on an hourly basis. Moreover, since there is only one original oil painting like this, once it is sold, she will not be able to sell it again.

The dealer, on the other hand, runs what is essentially an art store and thus must consider the same factors as any other small-business owner. These include the cost of the gallery's rent, utilities, insurance, security, advertising, and the occasional catalogue. She must also cover the salaries of the staffers

who pack and unpack the artworks, install them for exhibitions, pour the wine at openings, and deal with customers. Running an art gallery is an expensive, and very risky, business, so it is no wonder that dealers frequently take as much as 40, 50, or even 60 percent of the price of every work they sell. It is important to remember, therefore, that the "worth" of a particular artwork is roughly twice as much money as the artist eventually receives for it.

For a scholar, typically, the art she most values is priceless. It is impossible to assign a numerical value to sources of aesthetic pleasure, and few scholars (who are usually professional academics, specializing in one particular type of art, which they study, teach, and write about) are eager to do so. In fact, the training received by most art historians tends to avoid financial issues. In order to prevent any conflict of interest, a very rigid line has traditionally been drawn between studying, publishing, and exhibiting works of art (all practices that draw attention to those works, and generally increase the artist's prices), and attempting to sell those works or others by the same artist.

Artists devote their lives to making art, so for an artist a particular work will almost always be worth far more than she could possibly charge for it. In fact, some artists become so attached to certain works that they deliberately overprice them, hoping that no one will take them away. However, most artists derive immense satisfaction from knowing that their works are in the permanent collections of prestigious museums, displayed at prominent galleries, or owned by important private collectors. This increases their reputations, which in turn makes their art worth more. Ultimately, of course, art—like real estate or fine cuisine—is worth whatever someone is willing to pay for it.

QUESTION 5: *Why Does This Artwork Deserve to Be in a Museum?*

SHORT ANSWER
Maybe it doesn't.

LONG ANSWER
There are many reasons—aesthetic, political, and economic, among others—why a particular artist's work might be added to the permanent collection of a given museum or included in a temporary exhibition at the same institution.

Traditionally, art museums (unlike commercial galleries) existed primarily to provide a showcase for works considered important enough to stand the test of time. Members of the public have generally regarded the larger urban museums as places to improve themselves, by contemplating the works of the Old Masters. Today, ideas about art museums—like so much else—have undergone significant changes. As a result, it is no longer unusual to see a contemporary installation piece on display at the same institution that also owns several oil paintings by Rembrandt.

Generally speaking, though, the collections policies of most major museums remain essentially the same. They try to acquire and exhibit works that fill the holes in their permanent collections. The ideal, in most American art museums, is still to have high-quality examples by artists from all the periods and styles considered most important in the history of Western art, along with as solid a collection as the institution can afford (and for which it has room) of works from other parts of the world.

This seems simple enough, but just as the definition of good versus bad art can be difficult to pin down, so the relative importance of artists—from the distant and recent past—is notoriously changeable. There isn't room here to explore fully the changing ideas about what kinds of work constitute museum-quality art. Suffice it to say that art by women, non-Western art, decorative art (such as furniture, china, and glass), and even photography were not traditionally considered as important as painting, sculpture, and printmaking. As a result,

85. Jean-Léon Gérôme (French, 1824–1904), *The Carpet Merchant*, 1887. Oil on canvas, 32⅞ x 25½ in. (83.5 x 64.7 cm). The Minneapolis Institute of Arts. The William Hood Dunwoody Fund

they were not regularly collected by, or exhibited in, most major art museums until the last thirty years or so.

The pendulum of artistic taste moves remarkably quickly even just in terms of painting. A good example of this phenomenon is nineteenth-century French academic art—that is, precisely the sort of well-crafted, realistic, traditional paintings against which the pioneers of modernism (such as the Impressionists) eventually rebelled. As recently as the 1970s, most U.S.

86. Elisabeth Vigée-Lebrun (French, 1755–1842), *Portrait of Princess Belozersky*, 1798. Oil on canvas, 31 x 26¼ in. (78.7 x 66.7 cm). National Museum of Women in the Arts, Washington, D.C. Gift of Rita M. Cushman in memory of George A. Rentschler

graduate schools would have strongly discouraged advanced art history students from doing research on artists like Jean-Léon Gérôme (plate 85). That was because Gérôme, like all academic artists, was considered unimportant: an exquisite technician, to be sure, and very popular with his contemporaries, but hopelessly old-fashioned. Today, French academic painting is enjoying a well-deserved renaissance. Scholars now openly admit their interest in Gérôme, whose worth has risen considerably.

As a result, museums that own works by Gérôme no longer hide them in obscure hallways, and museums that do not have academic pictures are doing their best to acquire representative examples.[2]

Likewise, when I started graduate school in 1973, it would have been considered very odd to suggest writing a doctoral dissertation on a painter such as Elisabeth Vigée-Lebrun (plate 86), who was both female and a master of the Rococo style. Her work was considered too superficial, too frivolous, too pretty to be worth serious scholarly attention. Moreover, there was pitifully little information available about Vigée-Lebrun, or most other women artists. Over the last three decades, though, with the rise of the feminist movement, awareness of the contributions made by women artists—especially notable historical figures like Vigée-Lebrun (who was the toast of several European courts, and a particular favorite of Marie Antoinette's)—has grown exponentially. Perhaps more important, art that stresses sheer beauty is no longer suspect. Therefore, Vigée-Lebrun—and other artists of the period, both women and men—has also been "rehabilitated," and museums are treating her works accordingly.[3]

> *"Rockwell's great social painting remains, and Norman Rockwell remains, as well, as a sustaining presence in the public consciousness—a more important artist than his modernist and postmodernist detractors will ever acknowledge, and a more complex artist than his traditionalist defenders are likely to admit."*
>
> Dave Hickey, c.1999

As we saw in chapter 3, something similar happened recently to a very different artist: Norman Rockwell (plate 12). Not long ago, the idea that any illustrator—no matter how popular or successful—could have his works displayed in a museum of fine art would have been laughable. And yet, between 1999 and early 2002, a major retrospective exhibition of Rockwell's art, with a serious catalogue, toured the country, and he was the subject of a ninety-minute television documentary in the prestigious *American Masters* series.[4] How did this

happen? As with Gérôme and Vigée-Lebrun, Rockwell's art has not changed; it's our ideas about art that have been utterly transformed.

Of course, there are also numerous financial, political, and purely practical reasons why certain artworks are displayed and others are not in any given museum. Artists such as Rockwell and Grandma Moses, who have long been popular with major segments of the public even when their work was ignored by most critics, attract new visitors to museums. This is a fact that museum officials cannot ignore, in a country with limited governmental, corporate, and private support for the arts, especially during times of general economic distress. Moreover, pieces by an artist who has been championed by a senior curator, the museum's director, or a powerful potential donor are likely to be more visible than those made by someone with less important supporters. Regional museums typically champion the works of artists born and raised in—or otherwise associated with—those regions. Budgetary constraints are always an issue, especially as certain kinds of art become more sought after and therefore more expensive. And then there is the eternal problem of space. Most large museums own so many objects that they can never display more than 3 to 10 percent of their permanent collections at one time. But, along with all these very real points, one of the most influential elements in determining what the public sees is the constantly changing fashions within the art world.

QUESTION 6: Does Knowing about an Artist's Life Help You Understand the Work?

SHORT ANSWER
Sometimes yes; sometimes no.

LONG ANSWER
Obviously, studying an artist's biography—like learning about his technique, the aesthetic theories he found most useful, or any other aspect of his career—can enrich a viewer's understanding of his art. However, this knowledge does not necessarily explain any given work. People tend to assume that certain details in a

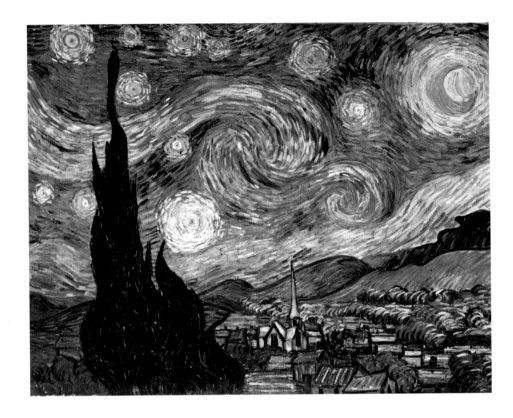

painting, or the overall mood it conveys, are reflections of that artist's life. Sometimes this is true, but just as often it is not. For example, the thick, concentric brush strokes that are crowded throughout Vincent van Gogh's *The Starry Night* (plate 87) create an impression of turmoil. Since the facts of this artist's highly troubled life (including several career and personal failures, financial difficulties, mental illness, and—ultimately—suicide) are well known, it is easy to assume a direct connection between that life and van Gogh's art. In fact, many of his other works (*Night Café* and *The Potato Eaters*, to name two examples) do seem fraught with emotional distress. But van Gogh also painted pictures— notably, his landscapes and his floral compositions—that are relatively calm, often genuinely lyrical, and without any obvious connection to the facts of the artist's life.

Likewise, the Expressionist paintings created before World War I by the German artist Ernst Ludwig Kirchner seem

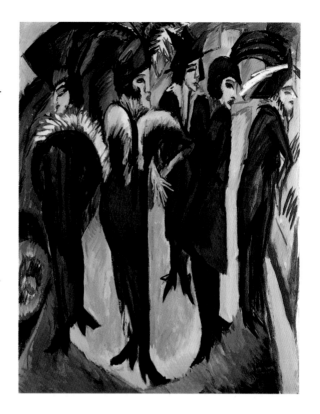

to foreshadow the artist's own sad fate. In his series of Berlin street scenes (plate 88), Kirchner deliberately distorted both the pedestrians' anatomy and the space in which they somehow manage to function. Forms are surrounded by thick black outlines, which makes them seem flat and unreal, and the bright, garish colors of the faces produce a profound sense of uneasiness. Here, there does seem to be a connection between these canvases and the artist's tragic life and death (like van Gogh, Kirchner committed suicide, years after the mental and physical breakdown he suffered while serving in World War I). But Kirchner's paintings also reflect the ideas behind Die Brücke (The Bridge), a group of young avant-garde artists of which he was a founding member. Along with his personal difficulties, Kirchner's broader view of the disturbing changes taking place in Europe at the start of the twentieth century helped shape his art in a significant way.

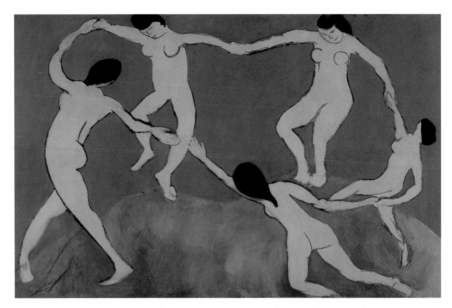

89. Henri Matisse (French, 1869–1954), *Dance (first version)*, March 1909. Oil on canvas, 8 ft. 7 in. x 12 ft. 10 in. (2.6 x 3.9 m). The Museum of Modern Art, New York. Gift of Nelson A. Rockefeller in honor of Alfred H. Barr Jr.

In contrast to van Gogh and Kirchner, the long-lived Henri Matisse created an extraordinarily large number of works, in various media, virtually all of which are infused with sensuality and joy (plate 89). The French artist took many of the same liberties as van Gogh and Kirchner—drastically simplifying and distorting colors, anatomy, and space—but the effect is anything but distressing. The lighter emotional tone of Matisse's work does not parallel his own life experience—which included early poverty and critical scorn as well as several serious illnesses. However, Matisse's art does clearly reflect his ideas about art. In one of his most famous statements, the Frenchman said, "What I dream of is an art of balance, of purity and serenity, devoid of troubling subject matter, . . . a soothing, calming influence on the mind, something like a good armchair that provides relaxation from physical fatigue."[5] This is quite a contrast to the writings of van Gogh, who in one famous letter to his brother Theo said of his painting *Night Café*, "I have tried to express the idea that the café is a place where one can ruin oneself, go mad or commit a crime."[6]

The point is that even though it is important to learn all one can about an artist's life, that information will provide only one key to appreciating her art. It is equally important to dedicate a significant amount of time to looking at the works themselves—in the original, whenever possible.

QUESTION 7: *Which End Is Up? How Can You Tell with a Totally Abstract Painting?*

SHORT ANSWER
Sometimes you can't.

LONG ANSWER
A newspaper cartoon from February 1913, one of many that made fun of the avant-garde art on display at the notorious Armory Show, focuses on the foreign contagion known as Cubism. A foppish Frenchman, complete with a top hat, is looking at his painting. He claps his hand to his head and exclaims, in pseudo-French: "Ah, mon Dieu! They have hang heem, my masterpiece, upside-down!" The joke is that the painting is simply a grouping of little cube shapes. Since it represents nothing, it would look essentially the same no matter which end was up.

Most of the time, of course, it's easy to figure out which side of a two-dimensional artwork is supposed to be on top. If the subject matter doesn't tell you, then the placement of the artist's signature probably will; if the work is already framed, the positioning of the wire picture hanger on the back is another useful clue. On the other hand, what happens when you encounter an unframed, unsigned, nonrepresentational, two-dimensional image that you want to hang up or reproduce in a publication? Many times, the work will "feel" right in one orientation, because the composition was planned to look best in that position. In rare instances, there will not be a single top, since the artist may actually want viewers to choose whichever orientation they like best. Georgia O'Keeffe once explained that she had designed a particular painting of flowers so that it could be hung with any one of its four edges as the top, and my

father sometimes signs two different sides of his monotypes, letting the viewer know that it is intended to work well in two different ways.[7]

This question can arise even with certain representational works—notably the paintings made by the German Neo-Expressionist Georg Baselitz. Since 1969 Baselitz has been best known for his series of thickly brushed, stylized human figures, which he deliberately hangs upside-down.

QUESTION 8 (Grand Finale): So, Exactly How Should I Approach an Abstract Painting, in Order to Get the Most Information—and the Most Pleasure—Out of It?

SHORT ANSWER
Read what follows.

LONG ANSWER
First of all, try not to worry about how you think you are supposed to respond to the painting. The most important, and the most useful, thing you can do is to relax and simply allow yourself to react. If possible, find a nearby bench—or bring one of those folding gallery stools—so you can sit down and devote some time to this process.

Now, examine your gut feeling about this painting. What does it tell you? (Don't be afraid to be completely honest; after all, the only one who will know what you're feeling is *you*.) On a purely visceral level, do you like, dislike, or feel neutral about this painting? Using the tools you have acquired by reading chapters 1 through 8 of this book, try to figure out precisely *why* you feel whatever you do about this work of art. I'm not talking about major Freudian analysis, but rather about a combination of standard formal analysis plus as much self-examination as seems comfortable and relevant.

The specific kinds of analysis you do will depend, of course, on which painting you're standing in front of, and how your own experiences and ideas relate to it. Yet there are certain basic elements that can be explored to intensify your experience of any work of art. For example, what color(s) are in this

painting? What shades of those colors? Are there any specific shapes (versus an amorphous veil of color), and if so, what do they look like? How many of these shapes are there? Are their edges crisp and well defined, or soft and bleeding into each other? Does the painting, overall, seem flat, or do the colors and shapes give the illusion of depth?

What kind of paint or other media were used to make this painting? (This information should be on the painting's wall label.) How about the textures on the surface of the painting? Does it have a smooth, blended quality, or are there clots of thick paint? Can you make out any brush strokes, spatters, scrapes made with the back end of the brush, or marks left by the artist's fingers? Does the painting look as though it was painted slowly or with great speed?

Is the composition (the overall arrangement of colors and forms) of this painting symmetrical or asymmetrical? Either way, how does the artist manage to visually balance the work? How large would you estimate this painting to be? How important is its size, and how much more—or less—effective would it be if it were significantly larger or smaller? Is the support (the actual canvas) rectangular, square, circular, or some other shape? *Is* it in fact a canvas, or has the paint been applied to a wooden panel, a plastic sheet, or some other type of support? (Again, this information should be on the label.)

Speaking of labels, how good a job do you think this one does in giving you essential information without overwhelming you with unnecessary details? Would you prefer that the label included more, or less, information? How easy was it to *find* the label and to figure out which painting it belonged to? Consider the painting's title. Is it neutral (*Untitled*, *Painting #3*), or does it seem to hint at some sort of hidden subject matter? Either way, do you think this title works? If so, why? If not, how would you change it—and why?

The presentation of an artwork (like the presentation of a pizza, or anything else) can be critical in determining a viewer's initial response. Is the painting hung high on the wall, or low, or at eye level? What kind, and what amount, of light illuminates

the painting? Is its surface covered by glass (or Plexiglas), and if so, does this cause glare? Is the painting framed? If not, how do the edges affect your reaction to the work? If so, how do the width, color, texture, and ornamentation of the frame affect the painting? What color is the wall on which this painting hangs? Would you prefer a different color? How close are the other artworks nearest to this painting? Does it seem crowded in its present location? What *is* its present location?

Take some time off from your analysis of this painting. Wander through a few adjacent rooms, or go outside for a few moments to clear your head. Then come back to the painting you were studying: does it seem the same, or is it different, and if so, in what way(s)?

Having carefully considered each aspect of the painting separately, now put them all together to determine what the painting does for you, overall. What sort of mood does it put you in? Does it remind you of anything, either another artwork or something from your own life?

If possible, jot down a few of your major impressions of this painting. Come back to see it again in another month or so and determine if those first impressions have changed.

In an ideal world, your next step would be to carry your investigations into the library, the classroom, or onto the Internet. There, it would be interesting to learn about the artist's life, career, writings (if any), and reviews. It would also be illuminating to see a number of other paintings by the same artist, in order to understand how they compare to the one you have already experienced. As suggested in the answer to Question 3, you might also consider taking an art history course, attending a relevant lecture, or going on a guided tour. None of these things would be likely to change your initial gut response to the painting. But they might expand, and enrich, your understanding of it, and of art in general. However, the most important tool for approaching abstract—or any other kind of—art is *you*, your eyes, your emotions, and your mind. Part of the point of this exercise, and of this whole book, is to help you to use them all more effectively in looking at modern art.

NOTES

1. Exactly What Is "Abstract" Art?

1. This tendency of art historians to glorify the avant-garde has recently been called into question. During the last few decades scholars such as Rosalind Krauss, Suzi Gablik, and Thomas Crow have argued that this stress on the unconventional and experimental prevents viewers from appreciating the contributions made by traditional art. More than that, they point out that viewing twentieth-century art through the narrow perspective of the avant-garde implies a value judgment, whereby new-style art means "progress" and traditional art exists only to be rebelled against.

2. For a thorough, concise introduction to this subject, see Wolf-Dieter Dube, *Expressionism* (New York: Oxford University Press, 1972).

2. Why *Is* a Painting Like a Pizza?

1. For further information about Abstract Expressionism, see Dore Ashton, *The New York School: A Cultural Reckoning* (New York: Viking Press, 1973).

2. These works used to be known as "drip" paintings, though recent scholarship favors terms like *poured* or *spattered*. See, for example, Kirk Varnedoe's essay in *Jackson Pollock* (New York: Museum of Modern Art, 1998), 17, 78 n. 2. Varnedoe also includes a useful discussion of the extent to which Pollock controlled his compositions.

3. In a sense, an abstract painting by Mondrian is like a Scottish tartan—that colorful plaid wool fabric worn on special occasions. According to the Scottish Tartans World Register (www.tartans.scotland.net), there are more than 2,800 different types of tartans, most famously those worn to distinguish the members of a particular clan. But there are also regimental tartans, hunting tartans, mourning tartans, corporate tartans, and several other kinds. The website's description of the process known as "reading the tartan" (that is, analyzing the color and

pattern to identify its type) sounds like something out of *Artforum* magazine. Its sophisticated, highly complex discussion of underchecks, overchecks, pivots, and almost mystical references to certain optical illusions is every bit as sophisticated and complex as any analysis of avant-garde art.

4. For a clear, concise discussion of Mondrian's ideas about painting, see Herschel B. Chipp, *Theories of Modern Art: A Source Book by Artists and Critics* (Berkeley and Los Angeles: University of California Press, 1968), 315–16, 321–23.

3. MAKING AESTHETIC DECISIONS IN ART AND IN DAILY LIFE

1. In 1975 Davis covered the circular walls of the Rotunda at the Corcoran Gallery of Art, Washington, D.C., with a temporary floor-to-ceiling composition of vertical stripes; the painted colors contrasted sharply with the parquet floor and coffered ceiling and with the white marble neoclassical sculpture in the center of the room. Davis painted the Rotunda again in 1982. The artist also put his signature stripes on asphalt: examples include *Franklin's Footpath* (1972), a 31,709-square-foot painting set in front of the eastern entrance to the Philadelphia Museum of Art, and *Niagara* (1979), billed as the largest painting in the world, covering 43,680 square feet of the parking lot at Artpark, in Lewiston, New York.

2. A fascinating selection of comments about Davis's so-called classic stripe paintings can be found in Steven Naifeh, *Gene Davis* (New York: Arts Publisher, 1982).

3. Letendre notes that *hamsa* is the Hebrew word for "heat wave," which seems to have some relationship to the color scheme of this work. However, the artist also says that she determines a painting's title only after a work is completed and adds that she believes this title "has no real relation to the design of the painting" (letter to the author, 30 July 2001).

4. Scale is a tremendously important factor to consider when dealing with visual art. However, since we so often deal with such art indirectly, through reproductions published in books or slides projected onto a screen, it is a good idea to remind ourselves how misleading this can be. For example, all standard slides measure 2 by 2 inches, and therefore they tend to look more or less the same size when projected.

Yet the actual works depicted in those slides may be quite small (like the comic strip reproduced as plate 83), of modest size (such as the Braque landscape, plate 33), or enormous (Calder's *Stegosaurus*, plate 73). Without some frame of reference, often there is no way to guess how big an artwork is, without reading the caption with its reproduction, or—ideally—seeing the original piece.

5. An interesting study of this movement is James Meyer, *Minimalism: Art and Polemics in the Sixties* (New Haven, Conn.: Yale University Press, 2001).

6. Francis Colpitt, "Between Two Worlds," *Art in America* 86 (April 1998): 88.

7. Truitt herself hinted at an anthropomorphic interpretation of her columns when she said, "The line of gravity runs as the center of every one of my sculptures. In the same way that a line of gravity runs through the center of a person from the top of the person's head down to the feet." Truitt further noted that she places her sculptures "on their own feet, as I am on mine." Victoria Dawson, "Anne Truitt and the Color of Truth," *Washington Post*, 14 March 1987.

8. Ibid.

9. Interview with the author, 10 January 2002.

10. Truitt has often mentioned her extreme nearsightedness, which was not diagnosed until she reached the fifth grade. As a result, the artist says, during childhood, "I lived in a world composed of light and color and shape, which I did not see, but which I had to intuit. I had to use kinesthetic cues inside myself to see—to feel how big something was, how heavy it was, and where it was, because I couldn't see it. I couldn't get the details. Couldn't see the line. I saw proportion and color." Dawson, "Anne Truitt."

11. Dave Barry, "Eye of the Beholder," *Washington Post Magazine*, 7 September 1997, 32. Barry begins his column thus: "Like many members of the uncultured, Cheez-It-consuming public, I am not good at grasping modern art. I'm the type of person who will stand in front of a certified modern masterpiece painting that looks, to the layperson, like a big black square, and quietly think: 'Maybe the actual painting is on the other side.'"

For a decidedly nonhumorous discussion of why Picasso's work should not be regarded as "art," see Marilyn Vos Savant's column, "Ask Marilyn," *Parade*, 15 October 2000, 14. For her part, Vos Savant says, "I

believe Picasso's success is just one small part of the broader modern phenomenon of artists themselves rejecting serious art—perhaps partly because serious art takes so much time and energy and talent to produce—in favor of what I call 'impulse art': artwork that is quick and easy, at least by comparison."

12. "Yes . . . But Is It Art?" generated a storm of controversy, both from viewers who agreed with Safer and from those who felt he was unfairly one-sided in his discussion. Innumerable articles were published concerning the issues raised in this television program. *The Charlie Rose Show* broadcast a special panel discussion on the *60 Minutes* segment (with four guests: David Ross, then director of the Whitney Museum of American Art, critic Arthur Danto, artist Jenny Holzer, and Safer himself, as well as Rose). Soon thereafter the popular sitcom *Murphy Brown* ran an episode in which television anchor-reporter Brown (played by Candice Bergen) took on Safer's role, pooh-poohing the works of various (fictional) avant-garde artists and then participating in a panel discussion in which she had to justify her responses.

13. Yasmina Reza's 1995 play *Art* (translated by Christopher Hampton), has been phenomenally popular in many countries, including the United States. The plot of this play revolves around escalating tensions that threaten the long-term friendship of three middle-aged men. The catalyst for these tensions is the purchase, by one of the friends, of a five-by-four-foot white-on-white painting from a trendy gallery, for a large sum of money. As many writers have pointed out, the fact that Reza's drama was produced many decades after white-on-white paintings first became a significant force within the avant-garde art world hasn't diminished the uproarious audience response to the canvas, which appears frequently onstage.

4. PAINTINGS THAT PEOPLE LOVE TO HATE

1. The term was coined by the critic Louis Vauxcelles in his famous review published in *Gil Blas*, 17 October 1905. For further information, see John Elderfield, *The "Wild Beasts": Fauvism and Its Affinities* (New York: Museum of Modern Art, 1976).

2. Quoted in John Rewald, *The History of Impressionism*, 4th ed., rev. (Greenwich, Conn.: New York Graphic Society, 1973), 320.

3. Leonardo da Vinci, *Treatise on Painting*, trans. and ed. A. Philip

McMahon (Princeton: Princeton University Press, 1956), 36–38 and 40–43. Reprinted in Robert Klein and Henri Zerner, *Italian Art, 1500–1600, Sources and Documents* (Englewood Cliffs, N.J.: Prentice-Hall, 1966), 5.

4. The feature film *Pollock* (2000) was directed by Ed Harris, who also starred as the Abstract Expressionist painter. There is also a classic, and fascinating, documentary film made by Hans Namuth in 1950 that shows Pollock himself making several large dripped or poured paintings.

5. Dorothy Seiberling, "Jackson Pollock: Is He the Greatest Living Painter in the United States?" *Life*, 8 August 1949, 42–45.

6. A useful source on this topic is Rose Lee Goldberg, *Performance Art: From Futurism to the Present*, rev. ed. (London: Thames and Hudson, 2001).

7. All quotes and information here were taken from the BBCNews/ARTS website, under the heading "Turner Prize."

5. BENDING—AND BREAKING—THE RULES

1. Since antiquity, many artists have also participated in the atelier (studio) system. Master painters and sculptors employed studio assistants, including apprentices, who learned their craft through helping with large-scale projects. The contract for a particular painted altarpiece might specify, for example, that the heads of the Madonna and Christ be executed entirely by the master's own hand. It was understood that other atelier members would paint less important areas, such as the angels or background landscapes, according to the designs—and under the supervision—of the master artist.

2. David Hopkins, *After Modern Art, 1945–2000* (Oxford: Oxford University Press, 2000), 172.

3. For additional information about this, and other related works, see Nancy Holt, ed., *The Writings of Robert Smithson* (New York: New York University Press, 1979). For a broader view, see John Beardsley, *Earthworks and Beyond: Contemporary Art in the Landscape*, 3rd ed. (New York: Abbeville Press, 1998).

4. Frank Stella's *Prinz Friedrich von Homburg, Ein Schauspiel* (1998–2001) is a thirty-one-foot-tall structure made from stainless steel, aluminum, painted fiberglass, and carbon fiber. It is set on the National Gallery's East Building lawn, where it looks nothing at all like a painting.

5. A classic study of this movement is Lucy R. Lippard, *Pop Art* (New York: Frederick A. Praeger, 1966).

6. New Materials, New Rules

1. Perhaps the most famous example, before Ofili, was the Italian artist Piero Manzoni, who in 1961 sold cans filled with his own excrement. He entitled this series *Merda d'artista*.

2. It was clear, even at the time, that the brouhaha over Ofili's *Holy Virgin Mary* concerned many different issues, including political and religious questions, the funding of publicly supported art, and racism.

3. Norman Rosenthal et al., *Sensation: Young British Artists from the Saatchi Collection* (London: Thames and Hudson, 1999), uncredited biography on p. 199.

4. For some interesting perspectives on this subject, see Linda Weintraub et al., *Art on the Edge and Over: Searching for Art's Meaning in Contemporary Society, 1970s–1990s* (Litchfield, Conn.: Art Insights, 1966).

5. Much of the literature on Neo-Expressionism is written in either Italian or German. For a useful discussion in English, see the relevant sections of Donald Kuspit, *The New Subjectivism: Art in the 1980s* (Ann Arbor, Mich.: University Microfilms Research Press, 1988).

6. Installation art is a broad term that encompasses many things, including both Ferber's permanent sculptural environment and Pfaff's intentionally short-lived arrangements of forms. This term typically implies art that takes over an entire space. For a helpful discussion of installation art, see Robert Storr, *Dislocations* (New York: Museum of Modern Art, 1992).

7. Lyndsey Layton, "Those Northern Delights," *Washington Post*, 15 March 2000.

7. Art Invades Life, and Vice Versa

1. My favorite volume on this subject remains Robert Rosenblum's *Cubism and Twentieth-Century Art* (1961; reprint, New York: Harry N. Abrams, 2001), a masterpiece of clear and genuinely interesting writing about a challenging topic.

2. Kenyon Cox, "The Modern Spirit in Art, Some Reflections Inspired by the Recent International Exhibition," *Harper's Weekly*, 15 March 1913, 10.

3. In recent years, the increasingly blurred line separating fine artists from designers has threatened to disappear altogether. Such developments as the toasters and other common household items designed for a nationwide discount chain store by the noted architect Michael Graves, and exhibitions at major art museums devoted to motorcycles and the fashions of Rudi Gernreich indicate some major rethinking about what constitutes art.

4. For a good overview of this topic, see Robert Motherwell, ed., *The Dada Painters and Poets: An Anthology,* 2nd ed. (Cambridge, Mass.: Belknap Press, 1981).

5. In fact, *Fountain* illustrates just how complicated the questions raised by Duchamp can be. As its caption indicates, the *Fountain* illustrated as plate 67 is actually not the same urinal with which Duchamp caused such a fuss in 1917. According to the Duchamp scholar Michael Taylor (assistant curator in the Modern/Contemporary Department of the Philadelphia Museum of Art) and many other sources, the original *Fountain* "was mysteriously lost" after being displayed at Alfred Stieglitz's New York gallery, known as 291, soon after it was rejected from that initial exhibition. That *Fountain* was never found. Taylor explains that the urinal next appeared in Duchamp's work in 1950, when the New York gallery owner Sidney Janis asked him to participate in an exhibition documenting the Dada movement. Although Duchamp went shopping, he couldn't find a urinal he liked. Luckily, Janis located an acceptable one in a Paris flea market, so Duchamp signed and dated it—like the original. That version is now in Philadelphia. Taylor also notes that Duchamp later authorized the fabrication of numerous other replica urinals, including the one in plate 67. (All quotes are from an e-mail response by Michael Taylor to my questions, 21 August 2001.)

6. Proust's quote is reproduced on the walls of the Freedom Rotunda at the James A. Michener Museum of Art in Doylestown, Pennsylvania.

8. THE EMOTIONAL IMPACT OF (SOME) ABSTRACT ART

1. One of the best-documented examples of viewer hostility toward modern art is the scorn heaped by critics and public alike on the so-called Armory Show, a large exhibition of American and European artworks—including many Fauve and Cubist paintings—held in New

York in February–March 1913. (For the best account, see Milton W. Brown's classic book *The Story of the Armory Show*, 2nd ed. [New York: Abbeville Press, 1988].) Critics labeled the show "freakish," "mad," and "subversive"; cartoonists showed visitors standing on their heads in a desperate attempt to "see" something within the Cubist canvases.

The most intense hostility was reserved for Marcel Duchamp's 1912 Cubist painting *Nude Descending a Staircase #2*, the title of which seemed to promise both a figure and some action, neither of which most gallerygoers could make out. Duchamp's *Nude* became the subject of innumerable puns, jokes, contests, and cartoons. Critics called it "an explosion in a shingle factory" and "a staircase descending a nude." *American Art News* offered a $10 prize for anyone who could find the elusive nude, and the *Chicago Tribune* published a serious article explaining how to do so, complete with a diagram. Overall, the negative response to the Armory Show remained unequaled in both magnitude and fervor until Mayor Giuliani tried to shut down the *Sensation* exhibition, eighty-six years later.

2. González is also credited with introducing his countryman Pablo Picasso to the practice of metal sculpture. Moreover, he was tremendously influential as a pioneer of welded-steel sculpture for avant-garde American artists, notably David Smith.

3. Peter Selz, *Art in Our Times: A Pictorial History, 1890–1980* (New York: Harry N. Abrams, 1981), 499.

9. COMMONSENSE ANSWERS TO SOME OF THE QUESTIONS MOST OFTEN ASKED ABOUT MODERN ART

1. From Whistler's "The Gentle Art of Making Enemies," 1890; quoted in John W. McCoubrey, ed., *American Art, 1700–1960: Sources and Documents* (Englewood Cliffs, N.J.: Prentice-Hall, 1965), 182.

2. For information about this artist, see Gerald M. Ackerman, *The Life and Work of Jean-Léon Gérôme* (New York: Sotheby's Publications/Harper and Row, 1986). For materials on academic art in general, see Albert Boime, *The Academy and French Painting in the Nineteenth Century* (New York: Phaidon, 1971). Also note the fascinating exhibitions, publications, and symposia organized by the Dahesh Museum of Art in New York, which is devoted to nineteenth-century academic art.

3. For a good overview of Rococo art, see Michael Levey, *Painting*

and Sculpture in France, 1700–1789, new ed. (New Haven, Conn.: Yale University Press, 1993). Most of the publications on female Rococo painters are in French; a notable exception is Mary D. Sheriff, *The Exceptional Woman: Elisabeth Vigée-Lebrun and the Cultural Politics of Art* (Chicago: University of Chicago Press, 1996).

4. See the catalogue for his recent exhibition, *Norman Rockwell: Pictures for the American People* (New York: Harry N. Abrams, 1999). Dave Hickey, a noted writer on art, is one of several prominent authors who have helped change people's ideas about Rockwell and about the importance—and validity—of beauty in art. Read, for example, Hickey's *The Invisible Dragon: Four Essays on Beauty* (Los Angeles: Foundation for Advanced Critical Studies, 1995).

5. Henri Matisse, "Notes of a Painter," 1908; quoted from Alfred A. Barr Jr., *Matisse: His Art and His Public* (New York: Museum of Modern Art, 1951).

6. Letter, September 1888, quoted in Herschel B. Chipp, *Theories of Modern Art* (Berkeley and Los Angeles: University of California Press, 1968), 37; original source, *The Complete Letters of Vincent van Gogh* (Greenwich, Conn.: New York Graphic Society, 1958), vol. 3, 31.

7. O'Keeffe makes this comment in the documentary film produced and directed by Perry Miller Adato, *Portrait of an Artist: Georgia O'Keeffe,* 1977.

ACKNOWLEDGMENTS

The production of any book—especially an illustrated one—is a collaborative process, so thanks are due to a great many individuals who helped to make this project possible. My initial interest in abstraction and other nontraditional forms of art goes back to early childhood exposure, through my parents, Gloria and Jules Heller, and their artist friends. However, my exploration of how people respond to avant-garde art was significantly shaped by the insights of an extraordinary teacher, A. Richard Turner, who also showed me that a scholar could have a sense of humor. Moreover, I have had the good luck to be able to discuss art, and other related matters, with a number of exceptionally generous colleagues, including Anna Beresin, Nancy Davenport, Jerry Lee Dodd, Cris Larson, Jody Mussoff, Andrew Petto, Robin Rice, William Rudolph, Sid Sachs, Patricia Stewart, and Faith Watson.

The years I spent delivering public lectures about abstraction for the Pennsylvania Humanities Council helped to hone my thoughts on these topics. For that opportunity, I am especially grateful to Robert Ackerman, who encouraged me to become a Commonwealth Speaker, and Laura J. Clark, who made it such fun to be one. I must also acknowledge the (sometimes unintentional) aid of the hapless students—at various institutions of higher learning—upon whom I have been inflicting art history since the late 1970s.

People say there are no more real editors, those highly intelligent individuals with extensive literary experience and impeccable taste who fight for the books they believe in and save authors from embarrassing mistakes. But Nancy Grubb is such an editor, and I thank her for agreeing to work with me a second time. Kate Zanzucchi, Princeton University Press's editorial

associate for art books, has worked tirelessly to acquire the illustrations for this book and to keep track of myriad loose ends; she is incredibly patient and has demonstrated great creativity in solving thorny editorial problems. I also wish to thank Patricia Fabricant, whose clear, witty design has made this book far more effective than it otherwise could have been, and Devra K. Nelson, the Press's excellent fine arts production editor. Invaluable assistance has also been provided by the Press's production manager, Ken Wong, and production coordinator, Sarah Henry. Thanks go, as well, to Miranda Ottewell, my wonderful copyeditor; Alison Pearlman, the eagle-eyed proofreader; and Catherine Dorsey, who compiled the useful index.

As always, Sara MacDonald (of the University of the Arts' Greenfield Library) was tremendously helpful at all stages of this project. I would also like to acknowledge the many different types of support provided to me, over the last twenty-four months, by a large group of stalwarts: Walter Campbell, Brian Feeney, Jasper Jalal, Mark Mahoney, the entire cast of "Noche Flamenca," Carole Regan, Robert Rochester, Helen Wasko, and Robert G. Regan.

Finally, this book could not have been published without the enthusiastic cooperation of innumerable private collectors, art dealers, museum staffers, and artists, who so kindly allowed us to reproduce their artworks.

SUGGESTIONS FOR FURTHER READING

DICTIONARIES

Atkins, Robert. *ArtSpeak: A Guide to Contemporary Ideas, Movements, and Buzzwords, 1945 to the Present*, 2nd ed. New York: Abbeville Press, 1997.

————. *ArtSpoke: A Guide to Modern Ideas, Movements, and Buzzwords, 1848–1944*. New York: Abbeville Press, 1993.

THEORY AND ARTISTS' WRITINGS

Chipp, Herschel B., comp. *Theories of Modern Art: A Source Book by Artists and Critics*. Berkeley and Los Angeles: University of California Press, 1968.

Danto, Arthur C. *The Madonna of the Future: Essays in a Pluralistic Art World*. Berkeley and Los Angeles: University of California Press, 2001.

Harrison, Charles, and Paul Wood, eds. *Art in Theory, 1900–1950: An Anthology of Changing Ideas*. Oxford: Blackwell Publishers, 1993.

Hickey, Dave. *The Invisible Dragon: Four Essays on Beauty*. Los Angeles: Foundation for Advanced Critical Studies, 1995.

Risatti, Howard, ed. *Postmodern Perspectives: Issues in Contemporary Art*. Englewood Cliffs, N.J.: Prentice Hall, 1994.

Stangos, Nikos, ed. *Concepts of Modern Art, from Fauvism to Postmodernism*, 3rd ed. London: Thames and Hudson, 1994.

SURVEYS AND GROUP-EXHIBITION CATALOGUES

Archer, Michael. *Art since 1960*. London: Thames and Hudson, 1997.

Benezra, Neal, and Olga Viso. *Regarding Beauty: A View of the Late Twentieth Century.* Washington, D.C.: Hirshhorn Museum and Sculpture Garden, 1999.

Collings, Matthew. *Blimey!: From Bohemia to Britpop: The London Artworld from Francis Bacon to Damien Hirst.* Cambridge, England: 21 Publishing, 1997.

Golding, John. *Paths to the Absolute: Mondrian, Malevich, Kandinsky, Pollock, Newman, Rothko, and Still.* Princeton, N.J.: Princeton University Press, 2001.

Haskell, Barbara. *The American Century: Art and Culture, 1900–1950.* New York: Whitney Museum of American Art, 1999.

Hopkins, David. *After Modern Art, 1945–2000.* Oxford: Oxford University Press, 2000.

Hughes, Robert. *The Shock of the New.* New York: Alfred A. Knopf, 1980.

Phillips, Lisa. *The American Century: Art and Culture, 1950–2000.* New York: Whitney Museum of American Art, 1999.

Rosenthal, Norman, et al. *Sensation: Young British Artists from the Saatchi Collection.* London: Thames and Hudson, 1998.

Selz, Peter. *Art in Our Times: A Pictorial History: 1890–1980.* New York: Harry N. Abrams, 1981.

INDEX

COPYRIGHT AND PHOTOGRAPHY CREDITS